PAST & PRESENT

MOUNT PLEASANT

OPPOSITE: On a busy day in downtown Mount Pleasant around the turn of the 20th century, the courthouse is surrounded by wagons. Businesses on the northern and eastern sides of the square include Badt shoe company, a phonograph store, and a hardware store. (Courtesy of Barry Hamilton.)

PAST & PRESENT

MOUNT PLEASANT

Melissa Fulgham, James McGregor, and Rex Allen

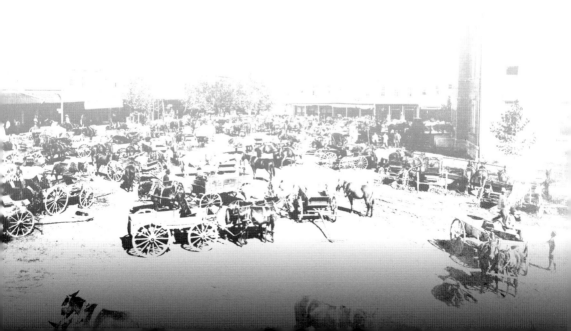

To our families who have endured our distraction and preoccupation with the past with grace and patience:
Scott Fulgham along with Brian, Arthur, and Eric Taylor, as well as
Heather and Katie McGregor, as well as
Missy Anderson, Nicole Peterson, Mandy Hagy, Ted Peterson, and Tammy Krause.
With much love.

Library of Congress Control Number: 2021950619

Published by Arcadia Publishing
Charleston, South Carolina

Printed in the United States of America

For all general information, please contact Arcadia Publishing:
Telephone 843-853-2070
Fax 843-853-0044
E-mail sales@arcadiapublishing.com
For customer service and orders:
Toll-Free 1-888-313-2665

Visit us on the Internet at www.arcadiapublishing.com

ON THE FRONT COVER: The courthouse is pictured surrounded by chinaberry trees, with the first gasoline-powered fire truck purchased by the city in 1915, and as it appears today, surrounded by crepe myrtles, with the Titus County Veterans Memorial on the southwest corner of the grounds. (Past, courtesy of *East Texas Journal*; present, courtesy of James Buckley.)

ON THE BACK COVER: Many spectators came out to see the Prosperity Special, a train of 24 new locomotives built by Baldwin Locomotive Works in Pennsylvania, when it paused in Mount Pleasant on its way to Los Angeles in 1922. (Both, courtesy of *East Texas Journal*.)

CONTENTS

ACKNOWLEDGMENTS

A number of organizations and individuals contributed research, photographs, stories, anecdotes, information, notes, journals, and encouragement that made this book a reality. Among these are the City of Mount Pleasant Public Library and Museum, which provided access to numerous historical items and images. Special thanks go to Traylor Russell, who wrote extensively on Mount Pleasant, and his son Robert Traylor Russell, who later helped him in that endeavor. Richard Loyall Jurney and the information he compiled in his 1961 book have also been helpful. Hudson Old and the *East Texas Journal* furnished invaluable assistance when compiling the images and information in this work. Northeast Texas Community College provided access to its photograph collection. Several of our colleagues at Northeast Texas Community College provided encouragement and technical assistance, especially Mandy Smith and Jodi Pack. Barry Hamilton, owner of the oldest retail establishment in Mount Pleasant, provided photographs and information on the history of the Mount Pleasant merchant community. Longtime residents also provided assistance to varying degrees. Mount Pleasant natives Rex Allen, John Williams, and Betty Gerhart graciously provided useful images and information as well. James Buckley, a student and artist, graciously took most of the modern photographs.

He didn't live to see it, but Lynch Harper would applaud the work done in publishing Past & Present: *Mount Pleasant*. He kept records. He worked in the county school superintendent's office when it existed. He was a Titus County tax assessor and collector when that was an elected office. He collected stamps, and when he began working for the City of Mount Pleasant and took responsibility for parking meter money, he began collecting coins. He had a passion for history and a love for order, so he made lists. He created a census from cemetery and funeral home records that included every cemetery in the county, both public and private. He wrote a history of churches. He bought a 35-millimeter camera, and when he began making the rounds shooting businesses in Mount Pleasant, he made notes and taped negatives to the back of his prints. After retiring, he walked to town every day, and they say you could set your watch by the time he walked into the Piggly Wiggly food store to buy a piece of fruit for breakfast. In the context of this book's intent to tell the story of a community then and now, Lynch Harper is a kindred spirit.

INTRODUCTION

Ancestors of the Caddo Indian tribes originally traversed the region where Mount Pleasant now exists. Members of the Caddoan Mississippian culture built large earthwork mounds and referred to the area as Pleasant Mound. Although erosion eliminated many of the oldest mounds in the area, settlers living in the region before 1900 commented on their presence. Settlers ultimately modified the name to Mount Pleasant.

Swuanano, Caddo for "good water," indicates one of the earliest draws for settlers to the region. The first documented Anglo settler, Kendall Lewis, settled along Swuanano Creek, which now drains into the Welsh Reservoir.

This pleasantly mounded, well-watered location became a focal point along the Clarksville-to-Jefferson road, built by Andrew Jackson Titus, which connected the capital of Red River County with what was once the busiest inland port in Texas: Jefferson. Following portions of the Choctaw Trace, the Clarksville Road allowed farmers and merchants to get their goods to and from market.

Due to its unique location in the corner of northeast Texas, surrounded by rivers with varying and confusing headwaters, the area that housed Mount Pleasant appeared on maps for both Red River County, the Republic of Texas, and Miller County, Arkansas. Only when Texas joined the United States in 1845 did the northeastern boundaries of Texas become clarified.

The first legislature of the state of Texas divided Red River County into smaller sections, naming one section after roadbuilder and early settler Andrew Titus and appointing Mount Pleasant as the Titus County seat. In 1850, the first US census to include Mount Pleasant revealed a population of 277. During the Civil War, Mount Pleasant served as a Confederate transportation depot, as befitted its location along the Clarksville Road.

The railroads arrived soon after. The expanded Tyler Tap railroad, which connected Tyler to the transcontinental rail lines being built at the time, ran through Mount Pleasant in 1878. St. Louis cotton capitalists, attracted by the possibility of lower cotton prices, took over, and the route became the St. Louis and Texas Railway Company, ultimately nicknamed "Cotton Belt." With the Cotton Belt line extending from Central Texas to Eastern Missouri, Mount Pleasant served as division headquarters until the 1920s. Eight passenger trains a day came through town, and crews were changed here. In the south part of town, numerous shops, a coal and water station, and a turnaround testified to the railroad's impact.

In 1900, the hilltop town became an incorporated city. Shortly thereafter, Morris Greenspun established the Mount Pleasant Telephone Company, the city's first organized telephone exchange. To untangle lines that would occasionally get wrapped when the wind blew, Greenspun walked along the lines with a fishing pole to straighten them out. When Southwestern Bell Telephone Company bought the exchange in 1904, it took over service for 174 customers.

A few years later, the Red Mineral Springs Development Company sought to establish a commercial resort on the south end of town, where colored mineral waters had attracted early natives and 19th-century bottlers. The Dellwood Resort opened in 1909 with a 70-room, Y-shaped resort overlooking a man-made lake. A dance pavilion, café, three springhouses, and outdoor activities made it an elaborate but costly enterprise to maintain. Although it did not have enough room to house all visitors in 1910, it folded a few years later, unable to turn a profit.

Chartered the same year Dellwood Resort opened, the Mount Pleasant and Paris Railroad, affectionately dubbed the "Ma & Pa," connected two growing cities plagued by poor roads and difficult river crossings. By 1910, Mount Pleasant's population had grown to 3,137.

Realizing the importance of dependable transportation, several prominent citizens joined the Good Roads movement. In the 1910s, North America's first transcontinental international highway, known as the Jefferson Highway, connected New Orleans, Louisiana, with Manitoba, Canada, and passed through downtown Mount Pleasant. Pillsbury Street became Jefferson Avenue, Kaufman Street became Madison Avenue, and a few other roads in town took on presidential names at that time.

Realizing the potential impact of easier travel on tourism and commerce, Mount Pleasant citizens pushed for improved roads, passing a $1-million bond. The Federal-Aid Road Act of 1916 established the Texas Highway Department, which passed on federal funds to local communities, including Mount Pleasant. One of the three commissioners appointed to the inaugural Texas Highway Department was Thomas Rusk McLean of Mount Pleasant.

The Texas Highway Department created Texas Highway 1 to connect Texarkana with El Paso, with the new road running through Mount Pleasant. The Bankhead Highway, the nation's first paved transcontinental highway, which owes its beginnings to that first Federal-Aid Road Act, connected Washington, DC, with San Diego by following along Texas Highway 1. Thus, at Mount Pleasant, the 1910 international Jefferson Highway, which runs north-south, intersects the 1916 Bankhead Highway, which runs east-west.

A few decades later, the Federal-Aid Highway Act of 1956 authorized the construction of the Interstate Highway System. The 40-mile segment of Interstate 30 that runs through rural Northeast Texas, connecting to US 67 in Mount Pleasant, was completed in 1971. It was the last section of Interstate 30 completed.

In addition to the rail and road systems that make Mount Pleasant the hub of Northeast Texas, the city has an excellent regional airport, recognized as the state's Airport of the Year in 2005. The airport also houses the world-class Mid-America Flight Museum, which has more historic flightworthy planes than any other museum in the nation. The museum has been involved with several significant restoration projects, including the first Air Force One plane used by Dwight D. Eisenhower, a project that brought national attention to the museum.

Despite its cozy, small-town appearance, the city, a micropolitan commercial center, includes globally recognized manufacturers such as Pilgrim's Chicken, Big Tex Trailer Manufacturing, and Priefert Farm & Ranch Equipment. In addition to being the utility trailer capital of the world, Mount Pleasant houses the nation's largest handmade chocolate manufacturer, Sweet Shop USA. Nationally recognized as a Main Street Community with extensive green spaces, the city boasts a significant amount of surrounding lake water, making it a bass fishing capital and putting it on lists of Texas top 40 travel destinations and top 100 small towns in America. The economic history of the city began as a travel route allowing the movement of products running the gamut from readily available and cultivated resources such as timber, cotton, milk, and cattle and evolved to mining for oil and lignite and, most recently, to sophisticated processes involving metal fabrication.

The city houses a nationally recognized, award-winning community college with the nation's only Work4College scholarship program that enables students to graduate debt-free. Northeast Texas Community College also houses the Shelby Automotive Program, which bears the name and sanction of race car driver and automotive design legend Carroll Shelby.

The city is growing, and newcomers may not realize the uniqueness and preciousness of the city's history and stories. This book is an attempt to share just a little bit of that by allowing the reader to take a literal journey around town as well as through time. The chapters are laid out geographically so that one can walk, drive, bike, race, ride, or gallop around town, noting the consistency across time as well as the changes that have taken place in the last century.

So, strap in, buckle up, or pick up your reins, and take a tour of the past and present of Mount Pleasant!

ON THE SQUARE

BUSINESS AND POLITICS, LAW AND ORDER

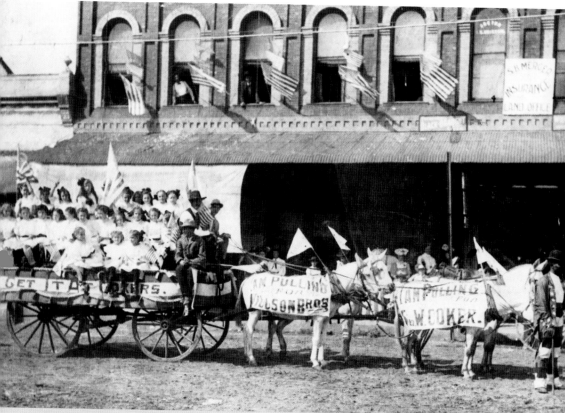

Created in 1848 by the Texas legislature specifically to serve as the county seat for the newly established Titus County, Mount Pleasant holds judicial and political prominence in the region. Located along the road that connected Clarksville with the port of Jefferson, the city also served as a hub for merchants and farmers seeking to buy and sell goods. Local merchants Willson Bros. and Coker's sponsored this wagon, posed in front of the Fitzpatrick Building, as part of an early 1900s Independence Day celebration. (Courtesy of the City of Mount Pleasant Library and Historical Museum.)

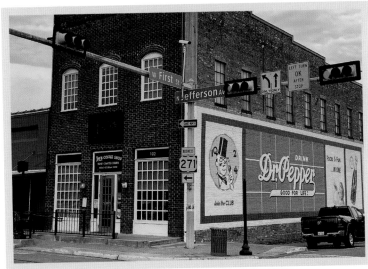

On the southeast corner of the square is the oldest structure downtown. "Thomas Caldwell, C.C. Carr, 1894" appears on the rear threshold. The Masonic lodge purchased the building in 1907, meeting on the upper floor and leasing out the lower floor. Scarborough's Grocery operated here from 1948 to 1963, with a Coca-Cola mural on the south side of the building. Today, Jo's Coffee operates from the building, with a Dr. Pepper mural in homage to the bottling plant once located one block to the north. Invented in 1885, Dr. Pepper is the oldest soft drink in the United States. (Past, courtesy of *East Texas Journal*; present, courtesy of James Buckley.)

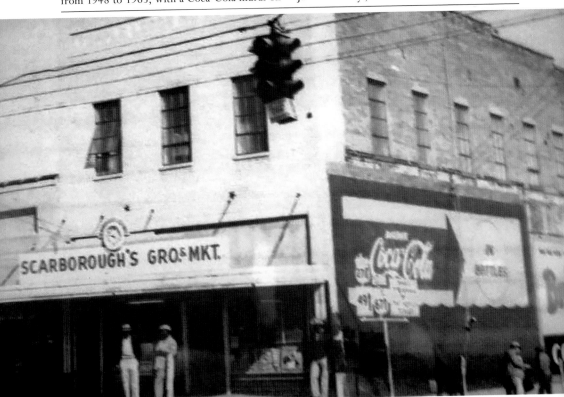

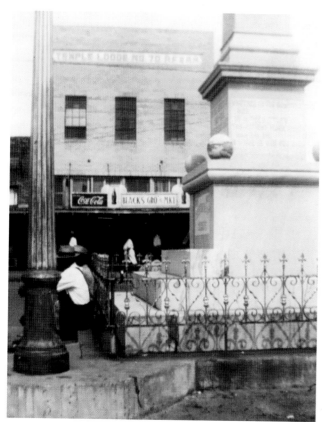

Take a few steps to the west for a different view of the same location. In the background can be seen Black's Grocery and Market, which predated Scarborough's Grocery. J.A. Black opened his store in that location after moving from Indiana in the early 1900s. (Past, courtesy of *East Texas Journal*; present, courtesy of James Buckley.)

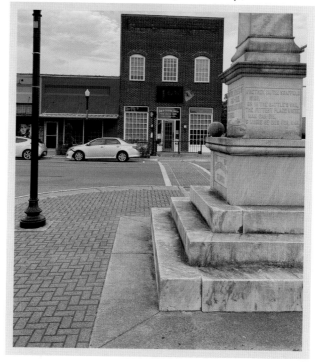

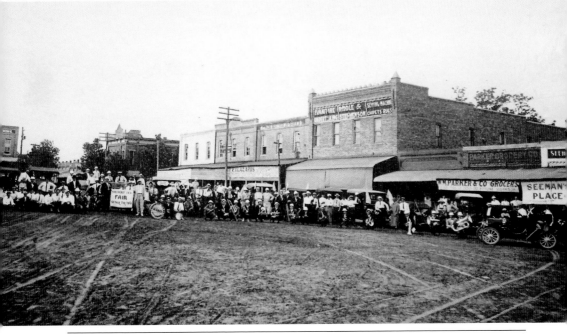

Moving north of the oldest structure, this photograph advertising the Northeast Texas Fair as "The Fair for You" shows a number of former businesses. Buildings that once housed Riddle Furniture and Undertaking, Parker Grocers, and Seeman's Place still stand. However, the three buildings on the northeast side, which used to house Lilienstern's, a law office, and Lazarus Groceries and Supplies, have been removed to make way for parking. The First National Bank can be seen toward the back in the past photograph. (Past, courtesy of John Williams; present, courtesy of James Buckley.)

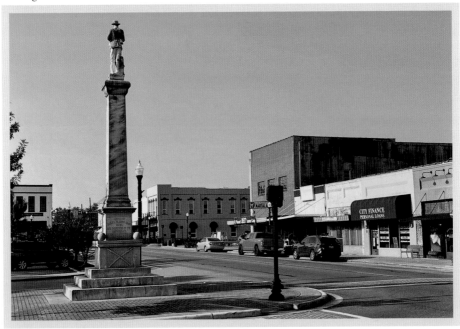

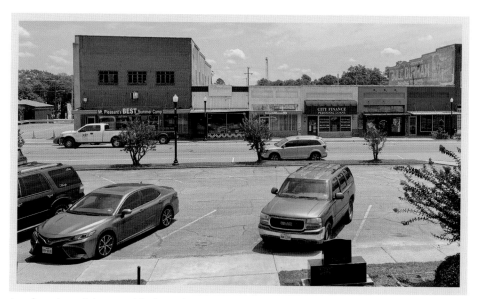

Another view of the same block can be seen in this 1940 photograph. Mason's hardware is in the middle of the block, although it would later move several blocks north. Although some of the buildings on the east side of the square no longer exist, the Bull Durham mural on the north side of the old Masonic Building is visible in both the past and present photographs. (Past, courtesy of *East Texas Journal*; present, courtesy of James Buckley.)

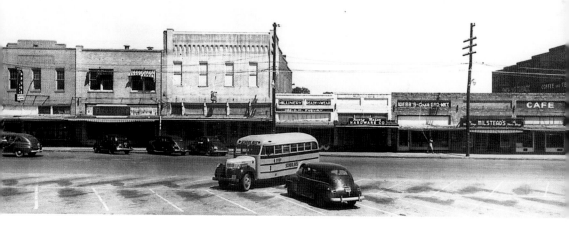

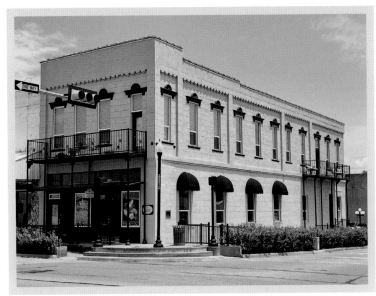

Coming to the northeast corner of the square, this building housed the First National Bank of Mount Pleasant. After the death of her husband in 1888, and at the urging of her brother-in-law C.C. Carr, Annie McLean Moores took over as bank president. In 1893, the *New York Times* referred to her as the "only woman president of a national bank." A member of the Exposition Board of Lady Managers, she helped finance the 1904 World's Fair in St. Louis. The building currently houses a restaurant and local catering business, the Butler's Pantry. (Past, courtesy of Rex Allen; present, courtesy of James Buckley.)

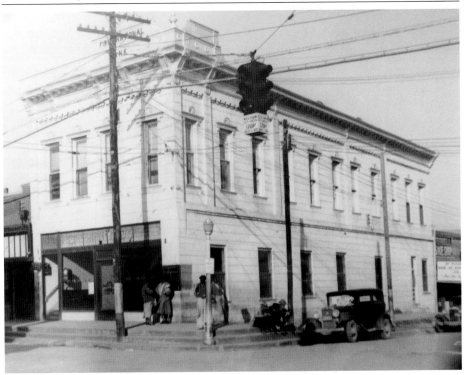

ON THE SQUARE: BUSINESS AND POLITICS, LAW AND ORDER

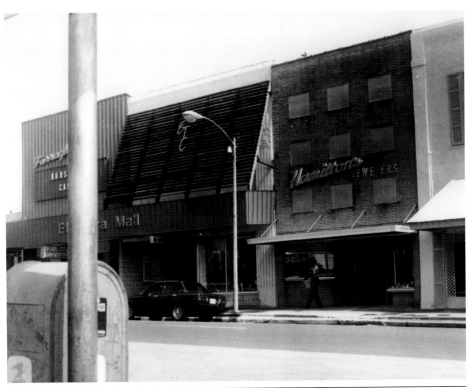

Turning west onto Second Street from Jefferson Avenue takes one to the north side of the square. Hamilton's Jewelry, which has been in operation since 1904, moved to its current location in 1945. The 1980s photograph shows Hamilton's Jewelry next to the Etcetera Mall, which operated from 1976 to 1989. Three Cleland buildings and one Lide building were renovated starting in August 1933. Plumb Crazy currently occupies the building, which has undergone recent renovations revealing the beautiful 1933 art deco facade underneath. (Past, courtesy of Lynch Harper/*East Texas Journal*; present, courtesy of James Buckley.)

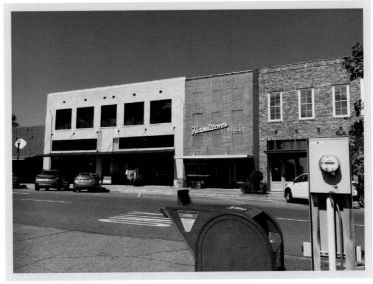

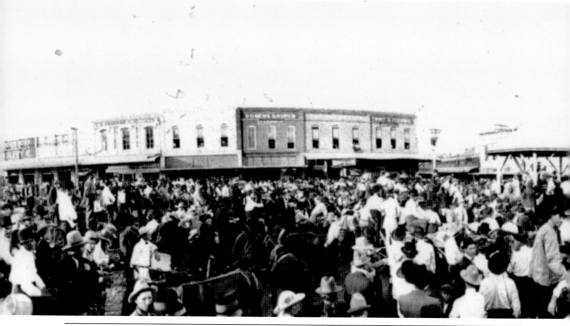

Continuing west on Second Street, looking north from the courthouse, the c. 1872 photograph shows a large crowd gathered for a public hanging. The square, with the Titus County Courthouse in the middle, served as a location for court proceedings and punishments. The businesses in the past photograph include Rogers & Roper hardware, Swint & Fleming drug, Vaughn & Co. Jewelers, and a saddlery. Today, the north side of the square remains a place where large crowds gather, now for musical and seasonal activities. (Past, courtesy of Lynch Harper/*East Texas Journal*; present, courtesy of James Buckley.)

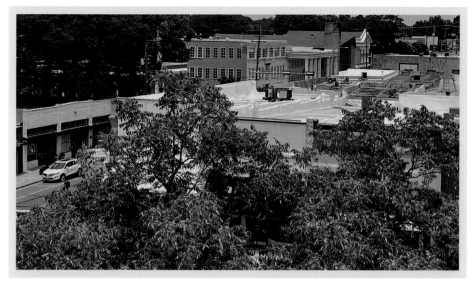

Coming to the northwest corner of Second Street where it meets Madison Street, one can see the pillars of the facade of the Merchant and Planters National Bank, built in 1907. The 1930s photograph shows the Southwestern Electric Power Company using the former bank building, with the First Baptist and First Presbyterian Churches in the background. Today, the bank building remains, although the original facade has been removed. It houses a law firm. The First Presbyterian Church can still be seen in the background. (Past, courtesy of Lynch Harper/*East Texas Journal*; present, courtesy of James Buckley.)

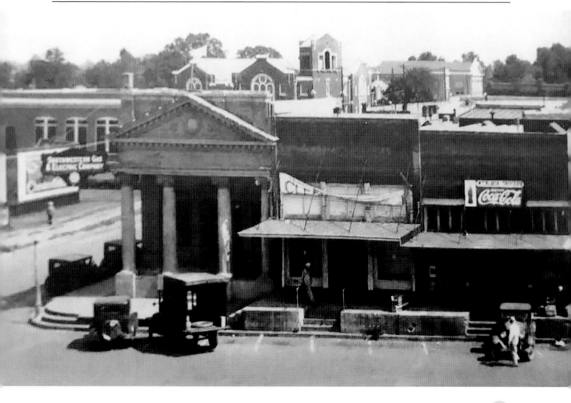

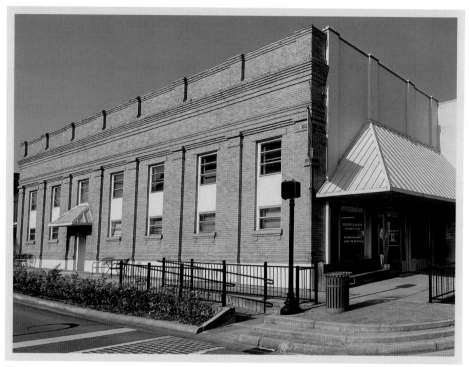

On the northwest corner is the structure of the Merchant and Planters National Bank, built in 1907. The building is currently occupied by Lesher and McCoy, attorneys at law, although the classical facade of the original bank is no longer there. (Past, courtesy of *East Texas Journal*; present, courtesy of James Buckley.)

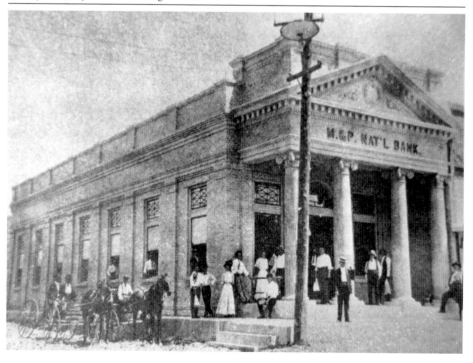

ON THE SQUARE: BUSINESS AND POLITICS, LAW AND ORDER

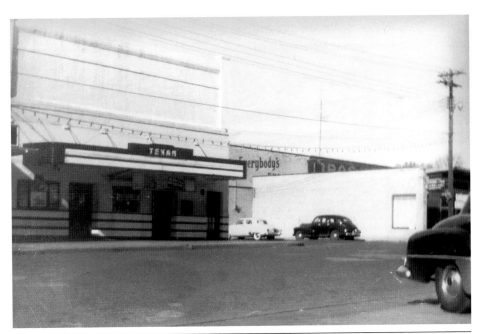

Turning south onto Madison Street, the once-popular Texan Theatre is pictured in the 1940s. The theater was a popular location to catch the latest Western and other motion pictures. In the background can be seen the former location of Everybody's Furniture. Today, the one-way street pays homage to its historic past with painted brick walkways. (Past, courtesy of City of Mount Pleasant Public Library and Historical Museum; present, courtesy of James Buckley.)

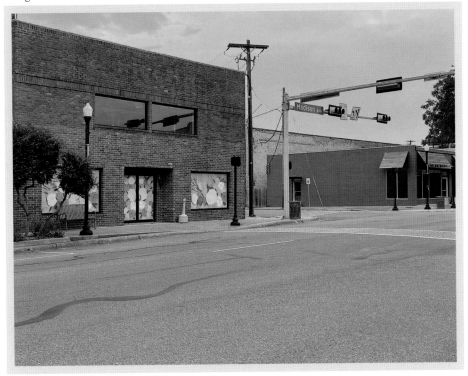

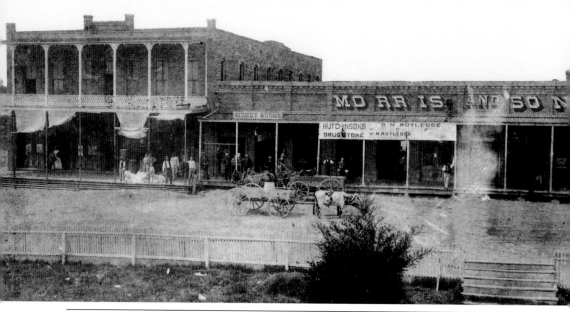

Continuing south, facing directly west on the square are some of the most popular and delicious present-day businesses, such as Nardello's Pizza Tavern and Laura's Cheesecake. In the late 19th century, the block housed Hutchinson's Drug Store and Morris and Son, as well as a business owned by Sidney Suggs, one of many local men who became active in the Good Roads movement. None of the buildings in the past photograph remain, as they were replaced by brick buildings in the early 1900s, including the F.W. Fitzpatrick, F.W. Stephenson, and Rogers Buildings. (Past, courtesy of City of Mount Pleasant Public Library and Historical Museum; present, courtesy of James Buckley.)

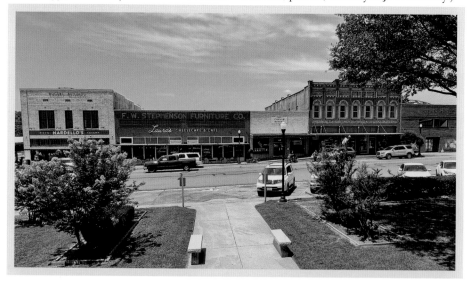

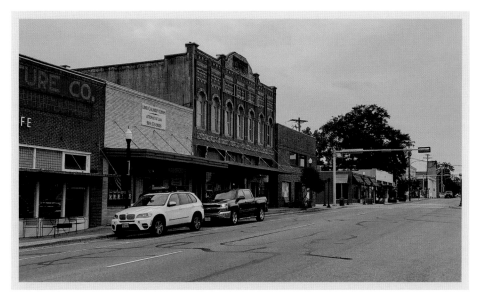

Looking north from the southwest corner of the square in this 1910 view, Confederate veterans line up for a parade to the Dellwood Resort south of town. The square's west side underwent significant change in the early 20th century. The Fitzpatrick Building, erected in 1900 and standing tall behind the paradegoers, is easily recognizable in the current photograph. Early-20th-century businesses on the block included Kelly Plows, Florey Brothers, Ellis Feed and Seed, Coker's, and Willson Bros. Hardware. (Past, courtesy of *East Texas Journal*; present, courtesy of James Buckley.)

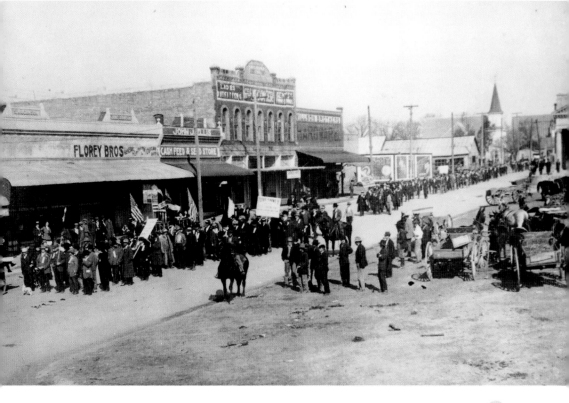

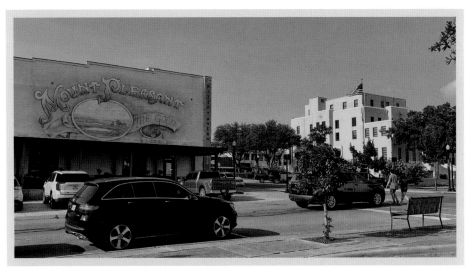

The far southwest corner of the square looking northeast toward the courthouse is the view in these photographs. With the courthouse's 1960s remodel, a nearly windowless shell was placed over the lower portion of the structure, earning the building recognition as the "ugliest courthouse in Texas." The 1990s remodel returned the courthouse to its 1940s-era art deco design. The *Mount Pleasant: The Good Life* mural on the south side of what is now Nardello's Pizza Tavern is another pleasant addition to the square. (Past, courtesy of Mount Pleasant Chamber of Commerce; present, courtesy of James Buckley.)

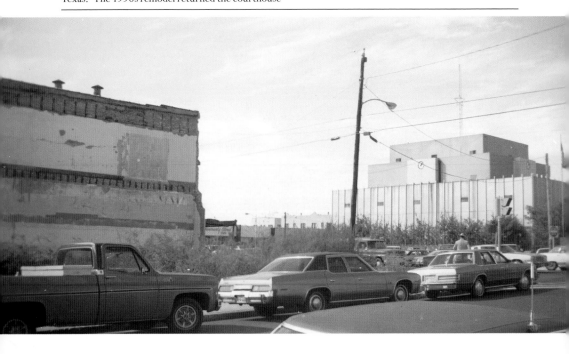

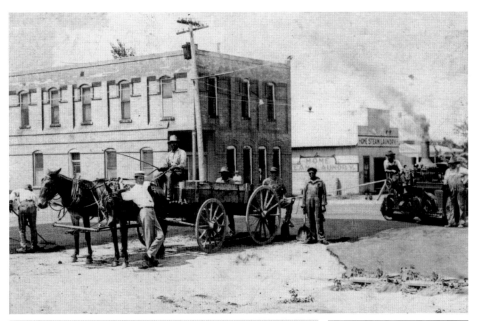

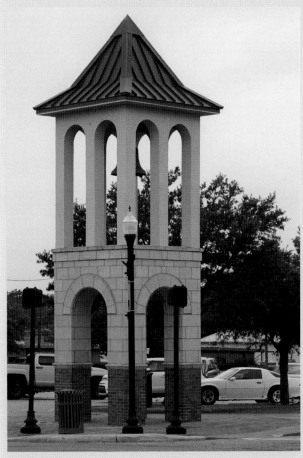

The southwest corner of the square, where Madison and First Streets meet, once housed Mount Pleasant's first hospital, the Blythe Sanitorium, which appears in the background of this February 1915 photograph of O.L. Crigler and his crew applying Mount Pleasant's first street paving. Dr. W.H. Blythe ran the two-story, 28-room hospital until his retirement in 1916, when A.P. Williams converted the building into a hotel. In 1955, J.B. Stephens bought the Pleasant Hotel, renaming it the Stephens Hotel. Today, a recreation of the bell tower from the 1895 Titus County Courthouse sits where the sanitorium/hotel once did. The bell tower houses the original 1895 bell. (Past, courtesy of Mount Pleasant Library and Museum; present, courtesy of James Buckley.)

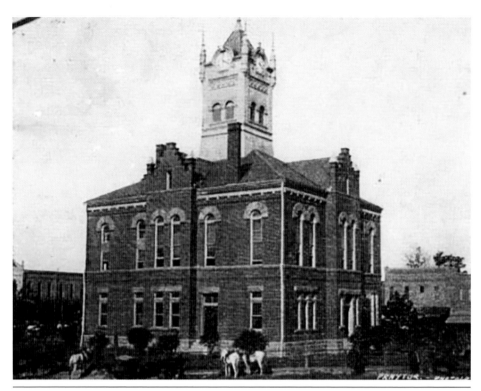

In the middle of the square is the Titus County Courthouse. Although the first three courthouses accidentally burned down, the fourth burned in 1895 when a county officer concerned about being caught embezzling sought to destroy incriminating records. Due to refacing and an additional story added to replace the bell tower, the courthouse looks dramatically different on the outside, yet the original 1895 structure remains underneath. (Past, courtesy of John Williams; present, courtesy of James Buckley.)

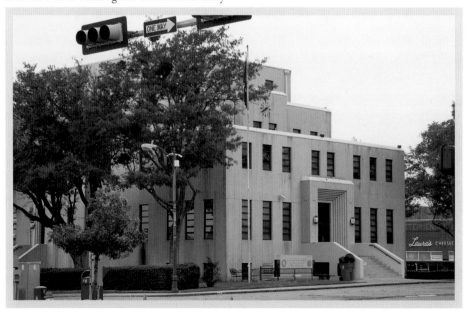

ON THE SQUARE: BUSINESS AND POLITICS, LAW AND ORDER

EAST SIDE

RAILROADS, GOOD ROADS, AND INDUSTRIAL INROADS

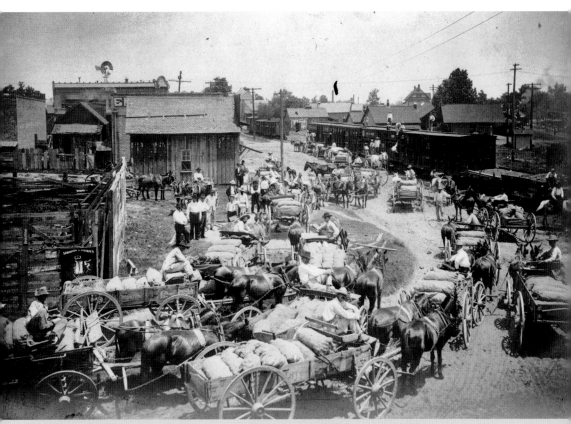

Over the years, businesses and industries that developed on the east side of town took advantage of the many forms of transportation that made Mount Pleasant a hub and connected the city with the rest of the world. Of greatest significance for the growth on the east side were the railroads. This photograph shows farmers in the 1890s bringing in wagonloads of potatoes to sell and ship. (Courtesy of John Williams.)

From the east side of the square, heading north on Jefferson Avenue, one travels along the Bankhead Highway, one of the nation's earliest transcontinental highways and the main traffic artery through Mount Pleasant. The Vogue Shoppe, once run by Ruth Lilienstern Old, currently houses a local periodical, the *East Texas Journal*. Run by the grandson of the Vogue Shoppe owner, the location proudly displays a historic "Bankhead Highway" sign. (Past, courtesy of Lynch Harper/*East Texas Journal*; present, courtesy of James Buckley.)

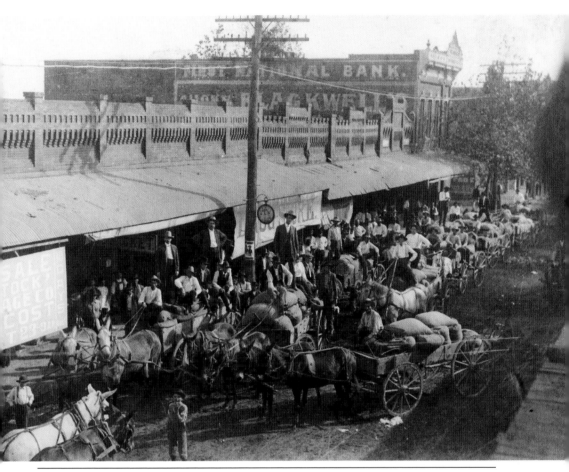

Head north on Jefferson Avenue, then look back to the south from the corner of Third Street. One will recognize the facade over the top of popular clothing store Glyn's Western Wear as the same seen in the past photograph of area merchants in town for a sale and auction in the early 20th century. The First National Bank building can be seen in the background. (Past, courtesy of John Williams; present, courtesy of James Buckley.)

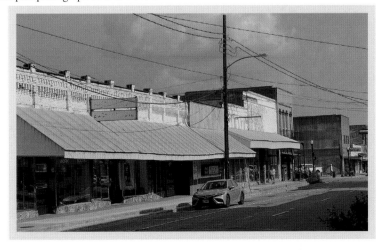

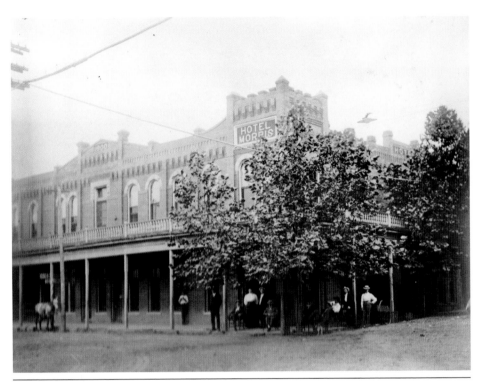

Directly on the southwest corner of the intersection of Third Street and Jefferson Avenue is the former Hotel Morris. Built in 1890 by Isaac Williams to house Mount Pleasant's first opera house, it became the Hotel Morris in 1900. Today, it serves as offices for several companies, including Lighthouse Counseling and Bird Old III, attorney at law. (Past, courtesy of *East Texas Journal*; present, courtesy of James Buckley.)

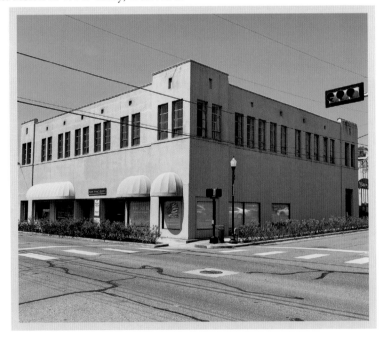

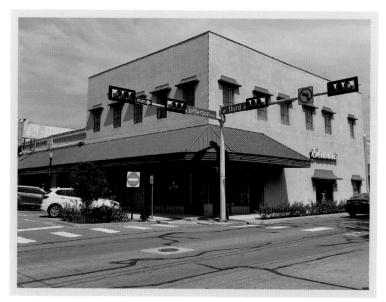

Directly across from the former Hotel Morris lies the Greenspun Building with its distinctive angled entrance. Morris Greenspun ran the city's first telephone exchange from here in 1902. The first lines ran from the doctors' offices to the drugstore, creating a strong connection with the medical establishment. In its early years, the Titus County Medical Society met in the building. Scott's Pharmacy occupied the building in the 1960s and 1970s before it became home to Denman Drilling and Imports Company. (Past, courtesy of John Williams; present, courtesy of James Buckley.)

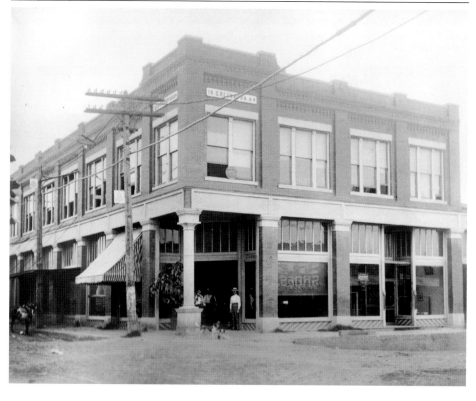

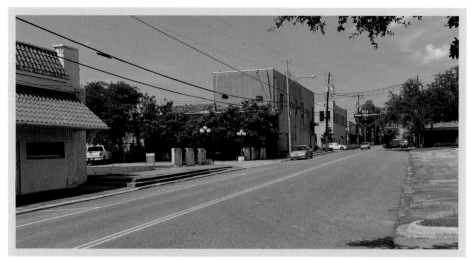

Turning right and heading east on Third Street, looking back toward Jefferson Avenue, one can see the former Hotel Morris. Lining the block in the past were Cooper Stable Service, Royal Bakery, and a meat market and restaurant. Most of the structures seen on the left, such as the stable and bakery, no longer exist, having made way for a parking lot to serve the variety of businesses on the square. The former Hotel Morris building provides office space and is a convenient landmark. (Past, courtesy of *East Texas Journal*; present, courtesy of James Buckley.)

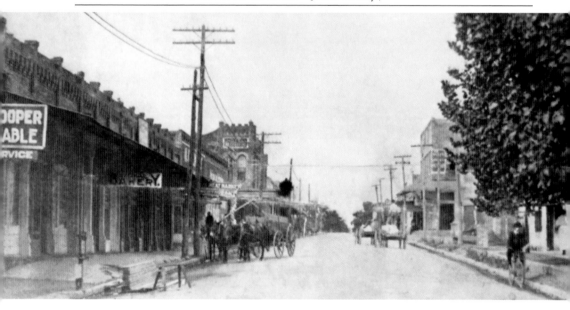

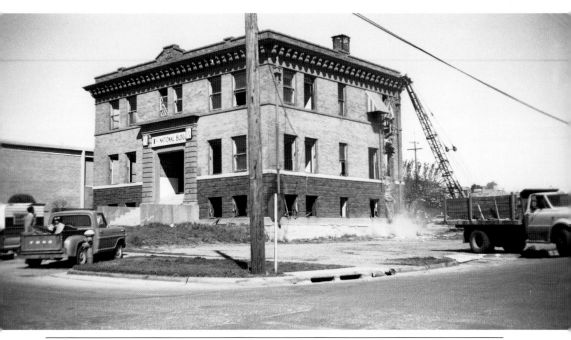

Heading to the northeast corner of the intersection of Third Street and Washington Avenue, one would find the old railroad building, pictured during its 1975 demolition. Prior to its demolition, it had been the temporary home of the First National Bank until its new building, partially visible on the left side of the photograph, had been constructed. Today that same space is occupied by VeraBank. (Past, courtesy of Lynch Harper/*East Texas Journal*; present, courtesy of James Buckley.)

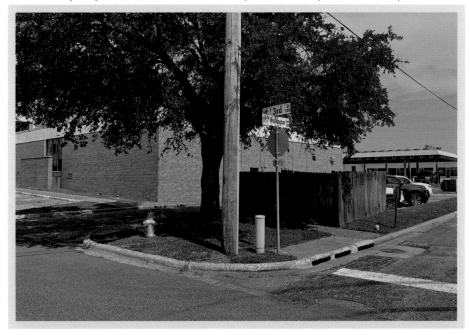

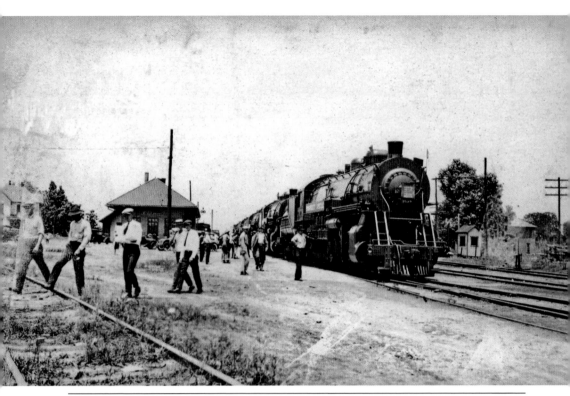

Head directly east down Third Street to the former Cotton Belt depot. In the early to mid-20th century, Mount Pleasant's depot served as a major hub, with trains connecting to Dallas, Tyler, St. Louis, and Memphis. At one point, eight passenger trains a day arrived in town, providing good business for boardinghouses such as the one owned by Claudia Self, seen in the background of the past photograph of the Prosperity Special in 1922. In September 2013, the Union Pacific railway demolished the depot, leaving a vacant lot. (Past, courtesy of *East Texas Journal*; present, courtesy of James Buckley.)

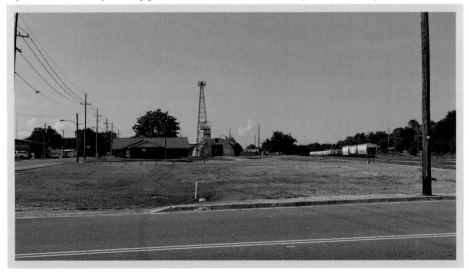

EAST SIDE: RAILROADS, GOOD ROADS, AND INDUSTRIAL INROADS

Return to Jefferson Avenue and head north a block. At the intersection with Fourth Street, turn and look south. In the 1967 photograph, one can see a bowling alley, a Western Union office, two cafés, and a drugstore along the formerly two-way Jefferson Avenue. In 1926, the US numbered highways began. Texas State Highway 1, which ran through Mount Pleasant, became US Highway 67 from Dallas to Texarkana. US Highway 271 connects Fort Smith, Arkansas, with Tyler, Texas. Signage for those roads can be seen in the past photograph. (Past, courtesy of *East Texas Journal*; present, courtesy of James Buckley.)

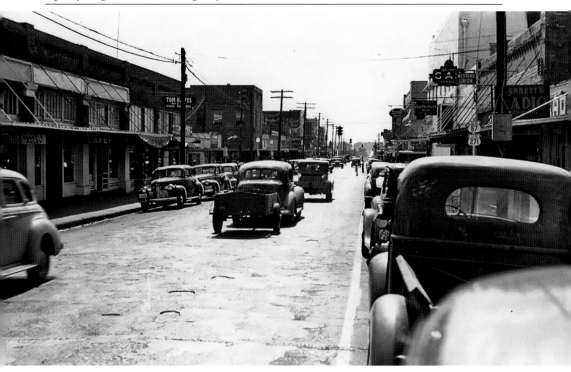

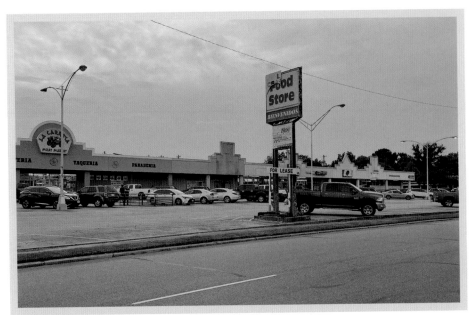

Continuing north along Jefferson Avenue to the block between Sixth and Eighth Streets, one can see the former location of the Town and Country Shopping Center. Gerald Lee "Pappy" Brogoitti operated the town's A&P grocery stores for 20 years, then opened the Piggly Wiggly at this location in 1948. The store originally faced Madison Street. New additions resulted in the main entrance changing to face Jefferson Avenue. The former Piggly Wiggly is now home to La Caretta Grocery Store. (Past, courtesy of Lynch Harper/*East Texas Journal*; present, courtesy of James Buckley.)

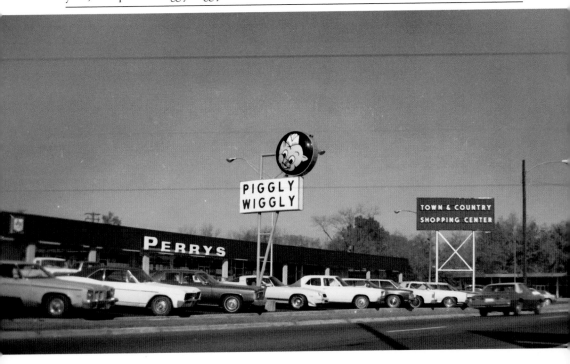

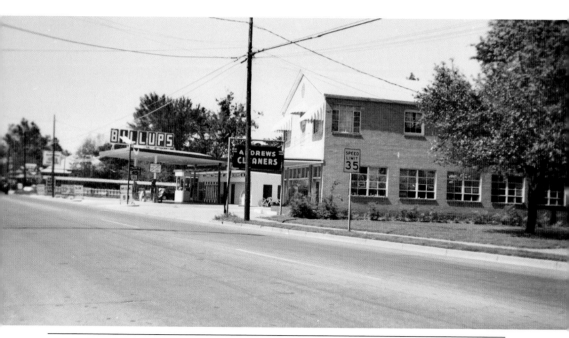

Heading north on Jefferson Avenue, just past the intersection of Tenth Street, one can see to the right the building that once housed Andrews Cleaners and today houses Redfearn Property Management and SER Inc. As this road once served as the Bankhead Highway and still serves as a US highway, the gas station in the background continues in operation, although under different ownership. The live oak tree pictured in 1973 is still there today. (Past, courtesy of Lynch Harper/*East Texas Journal*; present, courtesy of James Buckley.)

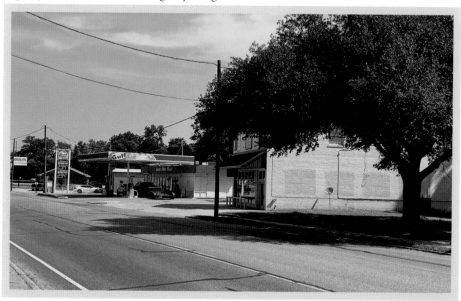

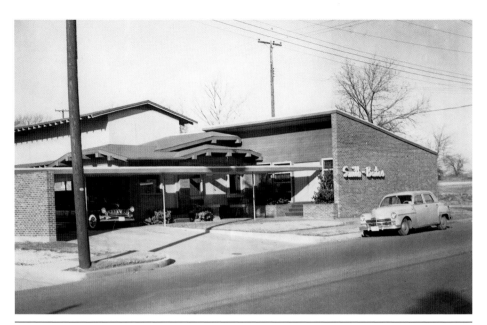

Continuing north to the intersection with Twelfth Street, this is the original location of Smith-Bates funeral home. Founded in 1948 as a partnership between Abb Smith and Lon Bates, the business has since become Bates-Cooper-Sloan. In 1996, the funeral home moved to its current location on the south side of the city. Looking across the location of the former funeral home's parking lot provides an excellent view of a patriotic mural honoring Mount Pleasant veterans. (Past, courtesy of Mount Pleasant Chamber of Commerce; present, courtesy of James Buckley.)

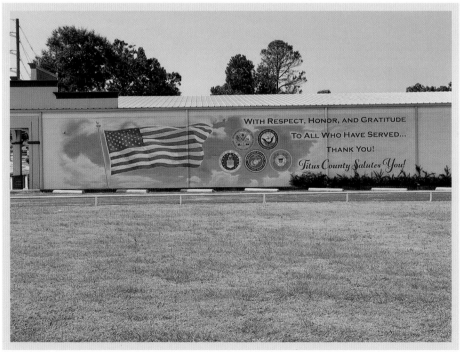

Moving north on Jefferson Avenue, the former Goates Court motel sat at the intersection with Fourteenth Street. The Goates Court offered "modern cabins" and "home-cooked meals" for travelers. The Falstaff Beer sign on the far left reflects the 1930s post-Prohibition era. Beer would be banned in the 1940s and not be legal again until 2019. Jeff Wellborn's State Farm insurance office now sits where the old hotel once did. (Past, courtesy of *East Texas Journal*; present, courtesy of Scott Fulgham.)

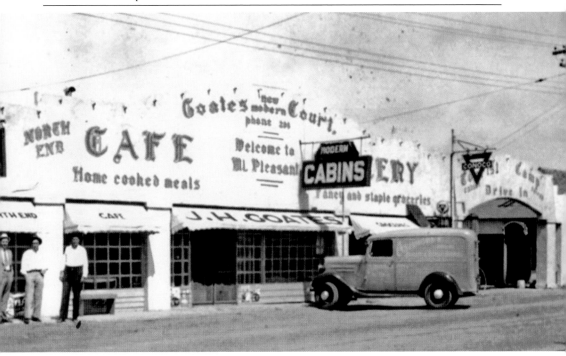

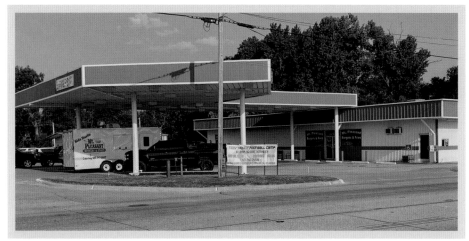

The old Bankhead Highway took a sharp turn at Jefferson Avenue and Fourteenth Street, following along present-day Fourteenth Street. At that corner, the Bankhead Service Station sold gas at 13¢ per gallon in the early 1930s. In the late 1930s, gas retailers began the current practice of adding fractions of a penny to the price. A modern version of the station now houses a local favorite, Mount Pleasant Burgers & Fries, which serves food prepared on a large open-face front-of-house grill. (Past, courtesy of Mount Pleasant Chamber of Commerce; present, courtesy of James Buckley.)

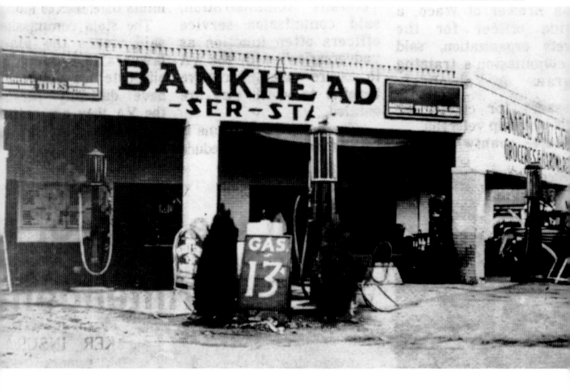

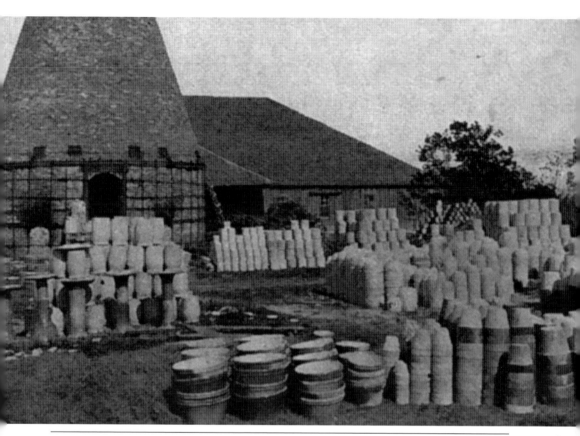

Continuing east on Fourteenth Street takes one to the site of the former Hogue Pottery. J.S. Hogue built his first pottery in 1865, moving to Mount Pleasant in 1921 to be closer to the best clay source. Titus County clay burns at a higher heat, producing a tighter, firmer piece, giving the three generations of Hogue Pottery a reputation for excellence. The business currently near that location, Sweet Shop USA, the largest handmade chocolate manufacturer in the country, also has a reputation for excellence. (Past, courtesy of Mount Pleasant Chamber of Commerce; present, courtesy of James Buckley.)

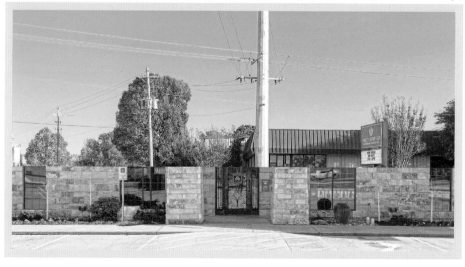

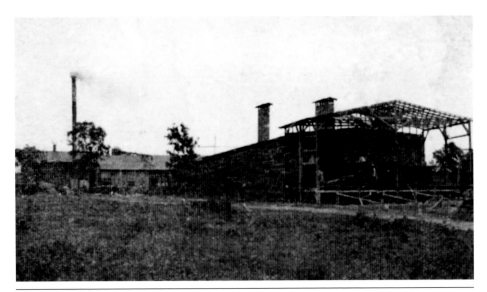

Turning south from Fourteenth Street onto Industrial Road brings one to the location of Hoffman Heading and Stave Company, founded in 1906. Hoffman built a railway to move timber from White Oak Creek to the factory. In 1908, Hoffman sold the right-of-way for the tram to the newly formed Mount Pleasant and Paris Railroad. Products from the company were shipped to Europe, South America, Asia, Australia, and all over North America. Currently, the site houses Taskmaster Components, which also ships its products all over the world as a global leader in the production of specialty tires primarily for utility trailers and recreational vehicles. (Past, courtesy of City of Mount Pleasant Public Library and Historical Museum; present, courtesy of James Buckley.)

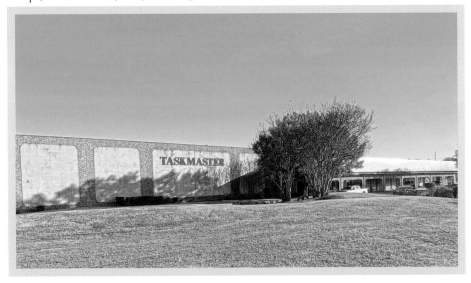

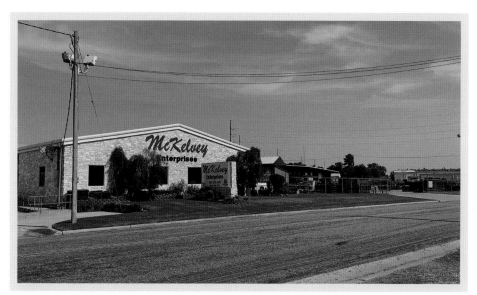

Continuing south along Industrial Road takes one to the site of the former Dunn and Gerhart EverReady Concrete Company at 1020 North Washington Street. Larry Dunn and Robert Gerhart worked in the construction industry for several years before opening their company in 1970. They sold the business in 1994, and the location currently houses part of local steel and trailer parts distributor McKelvey Enterprises. (Past, courtesy of Lynch Harper/*East Texas Journal*; present, courtesy of James Buckley.)

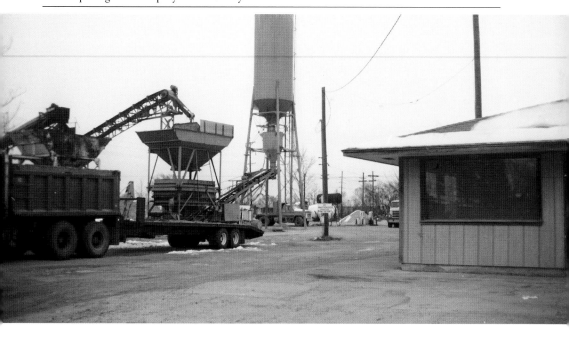

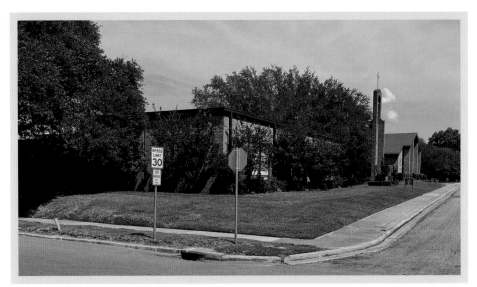

Moving south along Industrial Road, turn east onto Third Street until the intersection with Church Street. In 1893, C.C. Carr Sr. donated the land for a Methodist church. Before then, Methodists and Baptists shared a structure on Jefferson Avenue. After a fire, the church was rebuilt in 1924, with the entrance steps coming from the corner of Church and East First Streets. After a 1949 renovation and a new sanctuary added in 1967, the church entrance shifted farther north along Church Street. (Past, courtesy of *East Texas Journal*; present, courtesy of James Buckley.)

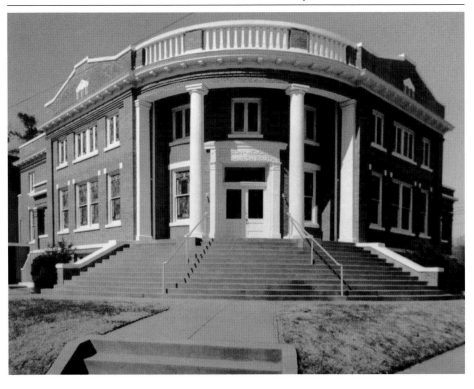

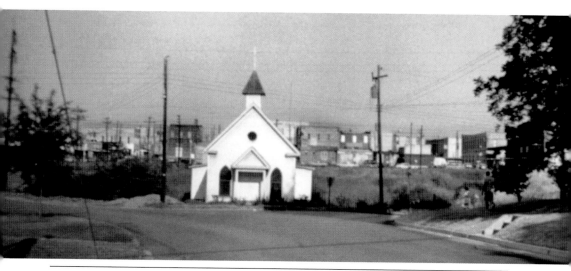

Heading west along Third Street and south on Lee Avenue, one arrives at the Y-shaped junction between First and Second Streets. In that junction sat the original St. Michael's Catholic Church, pictured here in 1964. Established in 1917 as a mission church of Texarkana, the church outgrew this small building and moved to a new location on six acres one mile east of the center of town. Thomas K. Gorman, bishop of Dallas–Fort Worth, came to town to dedicate the new church in 1964. La Villa Taqueria currently sits at the location of the former church. Downtown Mount Pleasant can be seen in the background of both photographs. (Past, courtesy of *East Texas Journal*; present, courtesy of Scott Fulgham.)

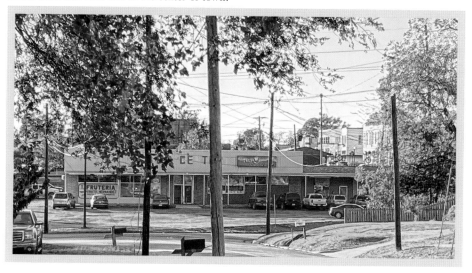

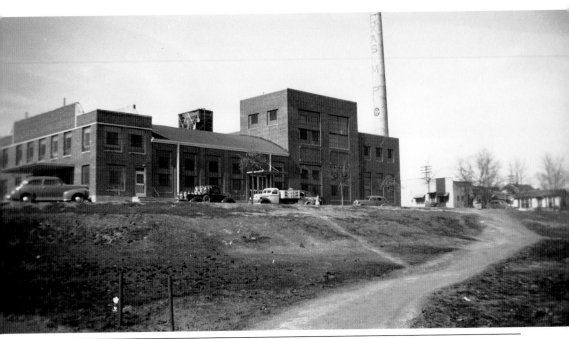

Continuing south on Lee Avenue, then turning west on Arkansas Street, brings one to the former Texas Milk Products Company plant. In 1928, the city sought to reduce cotton dependence. Twelve Jersey dairy cows were rotated through local farms to help create a new industry. Although dairy farms increased, beef production grew faster. The plant closed in 1960. The initials T.M.P.C. on the concrete stack, with Borden's name on the wall, testify to the varied raw resources that have made up the economy of the region at different times. (Past, courtesy of *East Texas Journal*; present, courtesy of James Buckley.)

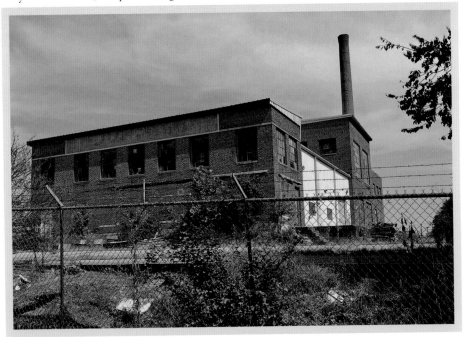

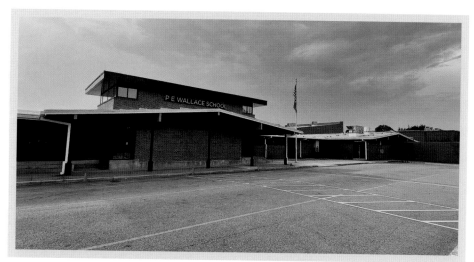

Heading southeast along Arkansas Street, Lide Avenue, and Choctaw Street takes one to P.E. Wallace Middle School. The school, pictured here in the mid-20th century, is still located at the intersection of Dunn Avenue and Choctaw Street. Parts of the original school remain, although the building has been extensively modified in the past 50 years. (Past, courtesy of Rex Allen; present, courtesy of James Buckley.)

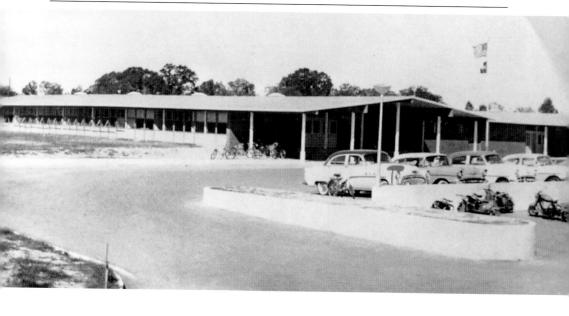

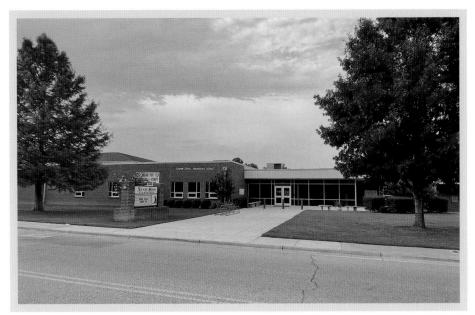

Heading north from Choctaw Street then east along First Street takes one to Annie Sims Elementary. Founded in 1911 as Eastside Ward on Third Street, just a short walk east of the Methodist church, it was the first Mount Pleasant school to appear in the public school directory for the state of Texas, initially with an 85¢ maintenance rate and 15¢ bond rate. The past photograph shows the school as it looked in 1963. The current school was built on the same lot but immediately to the east. (Past, courtesy of Rex Allen; present, courtesy of James Buckley.)

WEST SIDE

NEW AREAS TO RENDER EXPANSION

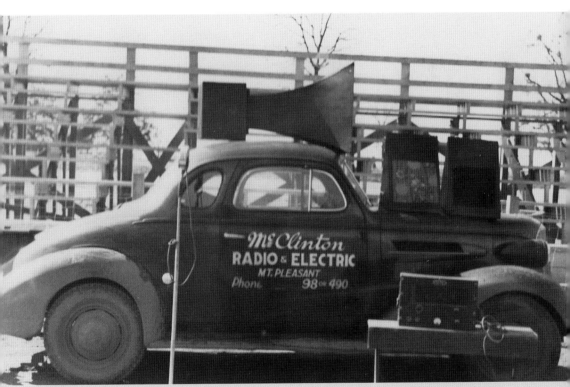

Initial development in the town remained close to the square, expanding first to the north and east, where the railroad tracks and earliest paved roads traversed. The west side of town was last to be developed but would go on to house a Fortune 500 company and the second-largest chicken processing plant in the nation, as J.B. Stephen's slaughterhouse and rendering plant eventually became the site of Pilgrim's Processing. Ewell McClinton advertised his radio and electric shop all over town, while also making town announcements, as seen in this image of his late 1930s Ford Coupe. McClinton also set up chairs outside his store, first on Madison Street and then Van Buren Avenue, to let people listen to the radio. (Courtesy of Harry McClinton.)

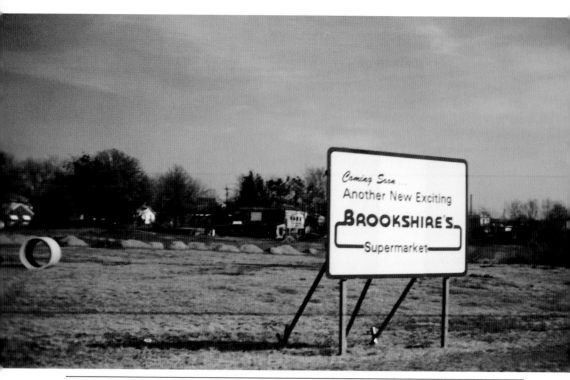

Moving west on Highway 49, known as Ferguson Road, underneath the railway trestle was not possible until 1962, when the earth beneath the railroad was removed to allow westward expansion of the state highways that met in Mount Pleasant. Co-author Rex Allen was among those who helped pull down trees, excavate swampy soils, and wrestle water moccasins to build the new route. Today, the road passes by Brookshire's Grocery and offers convenient east-west access in town. (Past, courtesy of Lynch Harper/*East Texas Journal*; present, courtesy of James Buckley.)

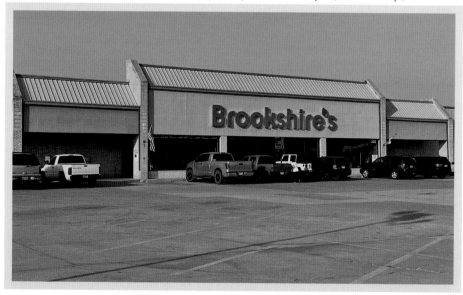

WEST SIDE: NEW AREAS TO RENDER EXPANSION

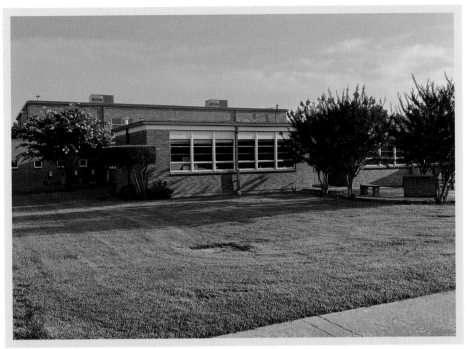

Moving northwest on Ferguson Road, take Martin Luther King Jr. Avenue south to School Road. Booker T. Washington, established in 1898 then rebuilt with a brick structure in 1926, served as the black school in the days of segregation. After 1968, it became the fully integrated Frances Corprew Elementary. Portions of the 1926 Booker T. Washington school and gym remain in use in the west wing of the school with a historical marker noting their significance. A hall of honor in the Corprew front hall notes distinguished graduates from Booker T. Washington School. (Past, courtesy of Lynch Harper/*East Texas Journal*; present, courtesy of James Buckley.)

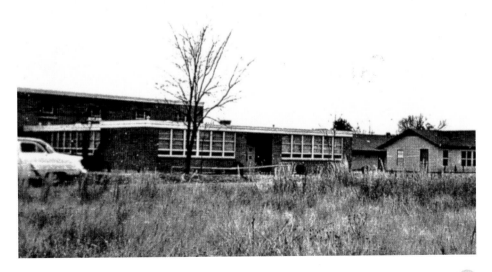

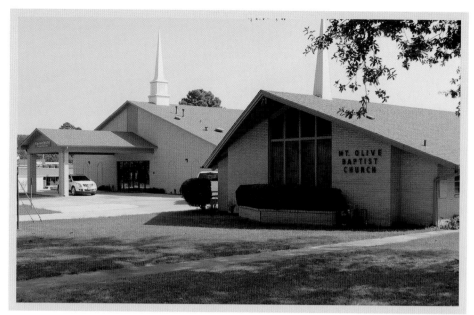

Head west on School Road, turn north on O'Tyson Avenue, and eventually come to the Mount Olive Baptist Church. Organized in 1873 under a brush arbor, with a stump being used for a pulpit and pine torches for light, the original congregation went from house to house in cold months until building a log cabin. The log cabin gave way to a frame house and eventually a brick structure in the 1930s, as shown in the past picture. The modern photograph shows the new brick church built in 1966 along with the 2018 expansion behind it. (Past, courtesy of Mount Olive Baptist Church; present, courtesy of James McGregor.)

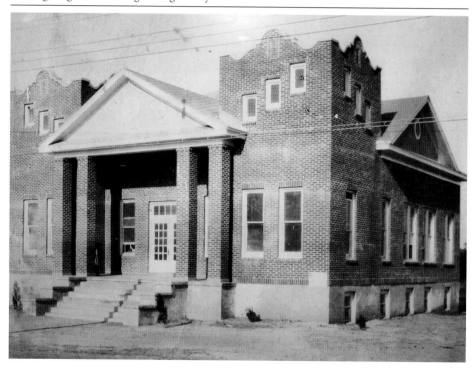

WEST SIDE: NEW AREAS TO RENDER EXPANSION

Continue north on O'Tyson Avenue, cross Ferguson Road, and head to the intersection with Sixth Street. At that corner stood the former West Ward School, built in 1945 after moving there from an overcrowded location closer to the town square. Originally, the elementary schools in town were given directional names, part of the ward system of the early 20th century. Today, West Ward has gone through several enlargements and is known as Vivian Fowler. (Past, courtesy of Rex Allen; present, courtesy of James Buckley.)

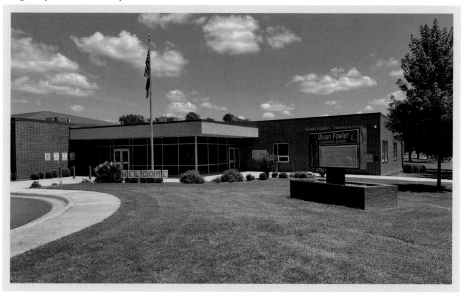

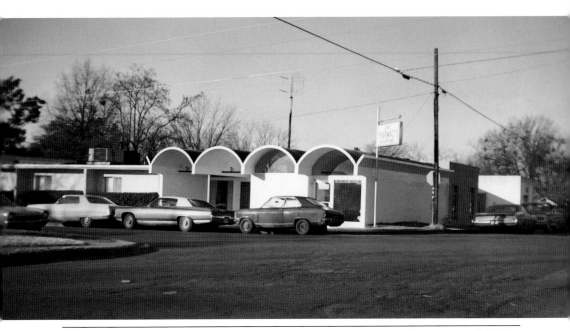

Traveling east on Sixth Street until the intersection with Madison Street brings one to the location of the former Mount Pleasant Clinic. Today, the City of Mount Pleasant Municipal Building is here, home to city government offices and the police department. City council meetings are held here twice a month. (Past, courtesy of Lynch Harper/ *East Texas Journal*; present, courtesy of James Buckley.)

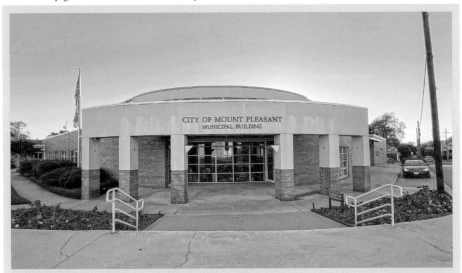

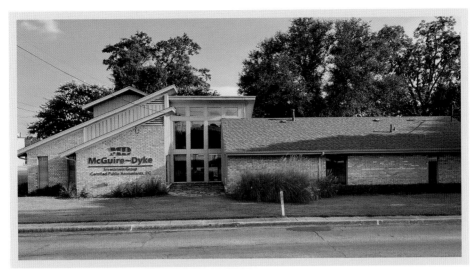

A block south, at the intersection of Madison and Fifth Streets, was the Crystal Ice Company. Texas Public Service provided ice for the city prior to the Crystal Ice Company. In the days before modern refrigerators, families depended on deliverymen to bring ice for their iceboxes. A card in the window would let the iceman know whether to chip off a block of ice weighing 25, 50, 75, or 100 pounds and bring it into the house, often carrying it directly to the icebox, dripping along the way. The McGuire-Dyke CPAs office, with its distinctive angled roof, stands in the same location. (Past, courtesy of Lynch Harper/*East Texas Journal*; present, courtesy of James Buckley.)

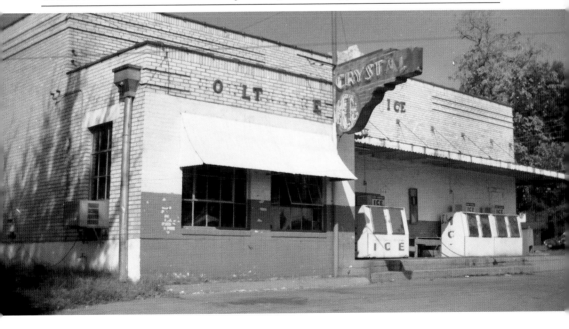

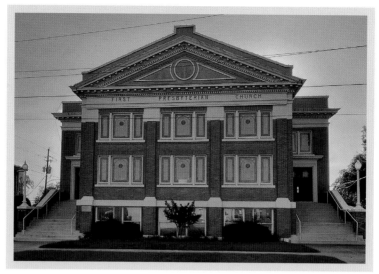

Immediately to the south, in the same block, is the First Presbyterian Church. Presbyterians are one of the oldest denominations in Mount Pleasant, dating back to 1860 in the Greenhill community. The First Presbyterian Church as it currently appears was constructed in 1923, but the original white frame structure at the same location was completed in 1883. (Past, courtesy of Mount Pleasant Presbyterian Church; present, courtesy of James Buckley.)

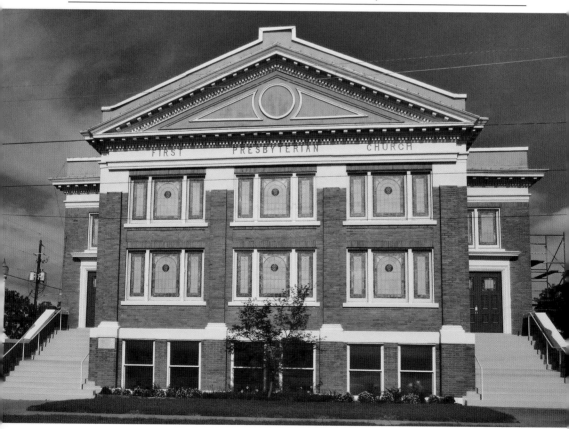

WEST SIDE: NEW AREAS TO RENDER EXPANSION

Immediately to the south of the First Presbyterian Church was the First Baptist Church. Starting with a frame building at this location, then adding additional lots over the years, First Baptist occupied the entire city block. The past picture shows a large sign welcoming new pastor L.L. Morriss. Today, the southern part of the structure, modified and painted white, houses Hightower Financial. The distinctive brick pattern of the sanctuary portion to the north is visible in both photographs. The First Baptist Church congregation relocated to a larger venue east of town on Highway 49. (Past, courtesy of City of Mount Pleasant Public Library and Historical Museum; present, courtesy of James Buckley.)

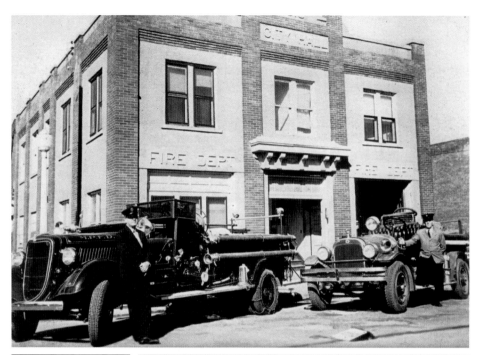

At the northeast intersection of Third and Madison Streets is the former fire department and municipal building. The fire department was established in this location prior to 1911. The past photograph shows the new Brockway fire truck purchased in 1915 to carry men and equipment to fires but which had no water tank or pump. The former municipal building has housed various businesses since. (Past, courtesy of City of Mount Pleasant Public Library and Historical Museum; present, courtesy of James Buckley.)

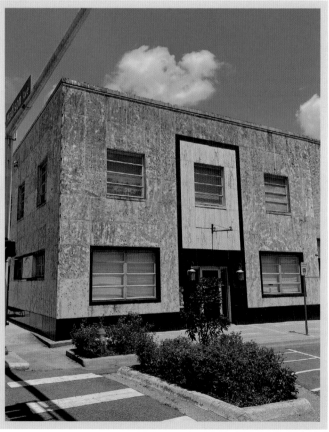

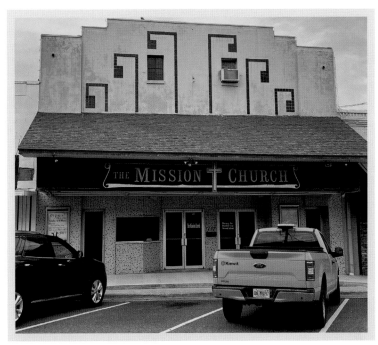

Turning east onto Third Street, one finds the former Martin Theater, the only theater between Texarkana and Dallas when it opened in 1913. J.E. Martin remodeled an existing building to copy a Chicago theater's style. Later owners changed the name to Titus Theatre and then back to Martin Theatre in 1937. A 24-page special edition in the local newspaper commemorated the reopening. After a stint as the Pleasant Jamboree, the building today houses the Mission Church. (Past, courtesy of City of Mount Pleasant Public Library and Historical Museum; present, courtesy of James Buckley.)

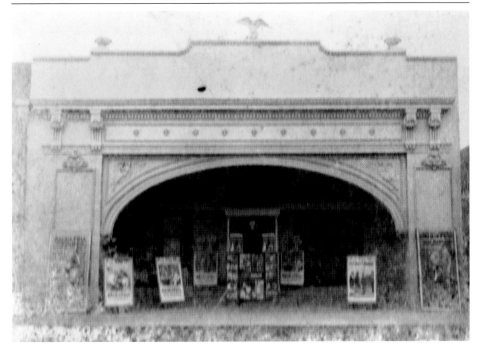

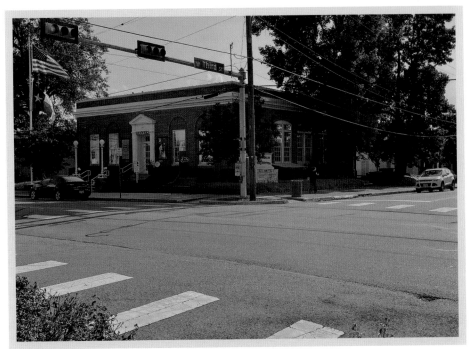

At the southwest corner of the intersection of Madison and Third Streets is the former Mount Pleasant Post Office building. Remodeled in 1967, it became the city library in 1969. In 2012, a new public library and museum was built a few blocks north. The building currently houses Hoover's Jewelry and Diamond T Outfitters, as well as the Edison Phonograph Museum on the lower level. (Past, courtesy of Lynch Harper/*East Texas Journal*; present, courtesy of James Buckley.)

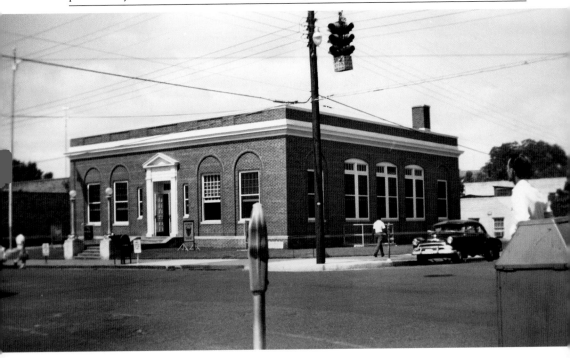

West Side: New Areas to Render Expansion

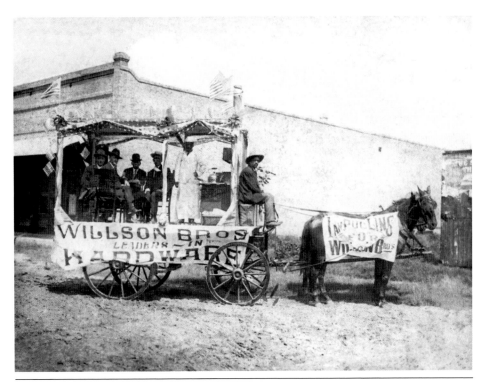

Continuing south on Madison Street, when it used to be called Kaufman, is the location in this photograph of a Willson Bros. parade wagon. Advertising themselves as "Leaders in Hardware," they pose in front of what is today Pearl's Kitchen, a handcrafted, from-scratch kitchen named by *County Line* magazine as "one of the best of the upper east side of Texas." (Past, courtesy of City of Mount Pleasant Public Library and Historical Museum; present, courtesy of James Buckley.)

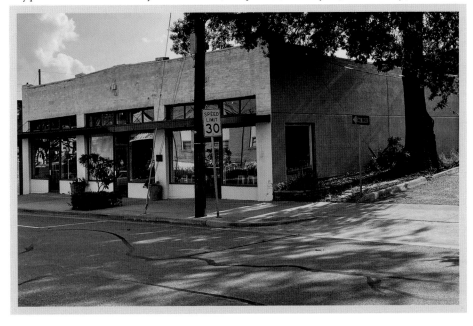

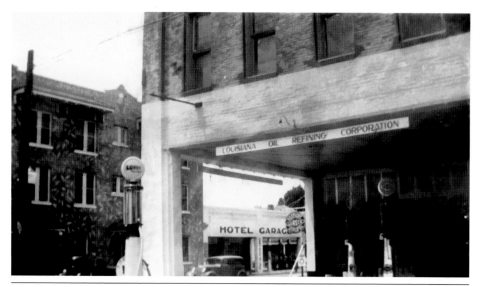

A block south, at the northwest intersection of Madison and First Streets, was the Louisiana Oil Refining Corporation (LORECO) service station. LORECO was incorporated in 1913 and went out of business in the 1940s. Note the visible hand-crank gas pump, the 1930s car, and the distinctive decorative stucco walls of the Pleasant Hotel. Today, the location houses the award-winning Nardello's Pizza Tavern, a farm-to-table restaurant named one of the "best of the upper east side of Texas" by *County Line* magazine. (Past, courtesy of *East Texas Journal*; present, courtesy of James Buckley.)

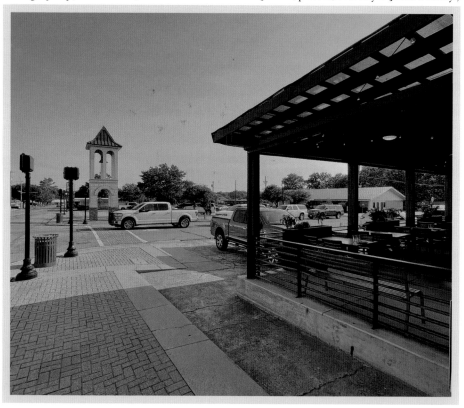

WEST SIDE: NEW AREAS TO RENDER EXPANSION

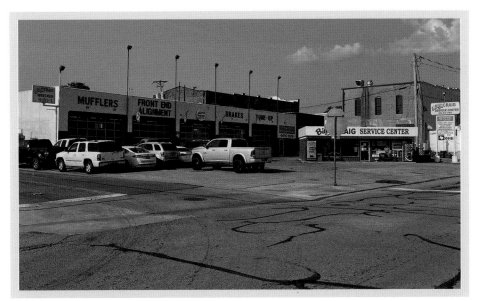

Moving west of the square onto First Street, one finds the former Fina gas station. Currently, Billy Craig Service Center meets motorists' needs at that same location. It has expanded to include towing and heavy-duty wrecker service, making use of the lot next door. (Past, courtesy of Lynch Harper/*East Texas Journal*; present, courtesy of James Buckley.)

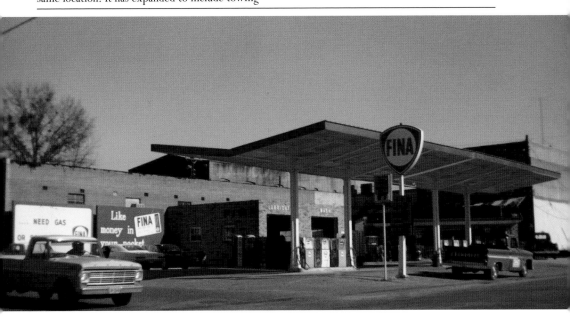

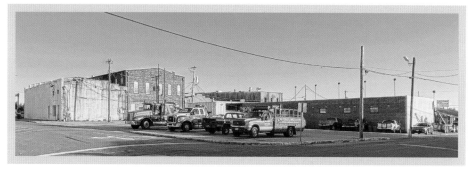

Turning north onto Van Buren Avenue, the southwest corner of Second Street is currently a paved lot. Starting with the 1891 maps, the location became the city jail. A brick building was constructed there in 1917 by C.W. Vaughan. The sheriff and his family lived on the bottom two floors with the prison cells, jury room, and gallows in the upper two stories. The last jail in the state with a gallows, although never used, it was ultimately torn down in 1999. (Past, courtesy of *East Texas Journal*; present, courtesy of Scott Fulgham.)

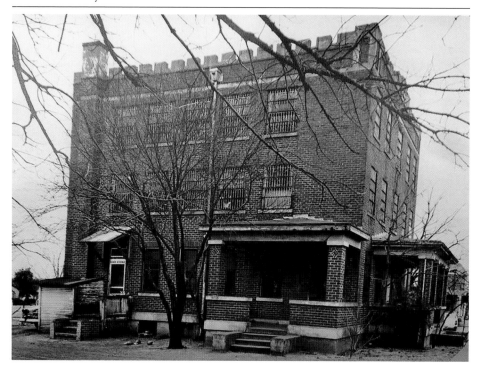

WEST SIDE: NEW AREAS TO RENDER EXPANSION

NORTH SIDE

HIGHWAYS, HOTELS, AND HEALTH

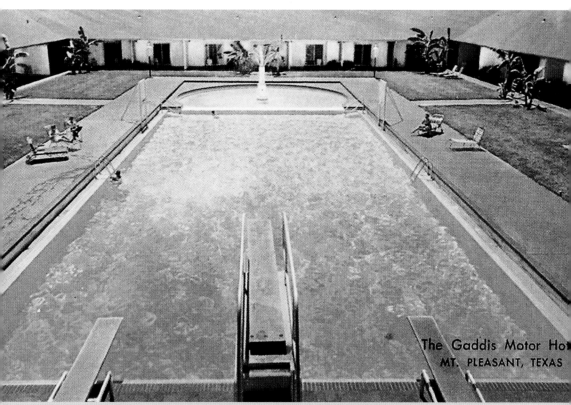

The Gaddis Motor Ho▶
MT. PLEASANT, TEXAS

Just as the railroad impacted the development of the east side of town, roads and highways shaped development on the north side of town. The Clarksville Road, Texas State Highway 1, the transcontinental Bankhead Highway, and Interstate 30 all ran nearby. Business and travel amenities sprang up along the routes. The Gaddis Motor Hotel, with its spectacular 5,000-square-foot pool surrounded by palm trees, was a favorite location for locals as well as travelers. (Courtesy of *East Texas Journal.*)

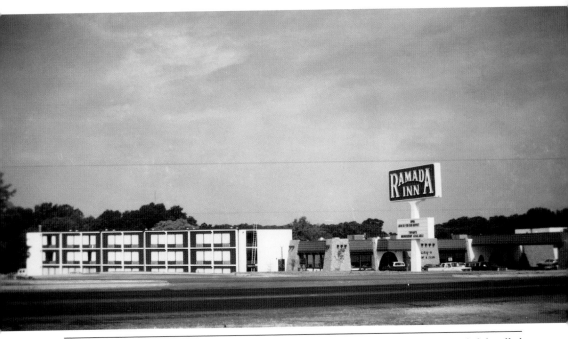

On the northwest corner of the intersection of Highways 67 and 271, a block south of present-day Interstate 30, lay the Ramada Inn, one of the many hotels built in Mount Pleasant to lure in travelers. The 1984 photograph shows the Ramada Inn, a chain founded in 1953. In addition to rooms, the Ramada offered a restaurant and club called Tiffany's. Today, the motel structure has a new name, Executive Inn, and houses a restaurant and bar called Backroads. (Past, courtesy of Lynch Harper/*East Texas Journal*; present, courtesy of James Buckley.)

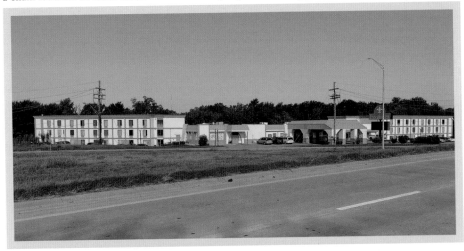

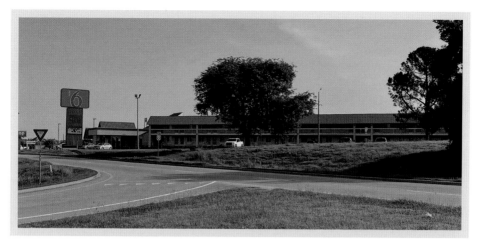

On the northeast corner of Highways 67 and 271 is the location of the former Holiday Inn. Chain founder Kemmon Wilson disliked the inconsistent variety of independent motels and wanted to create a more consistent chain, whose name was inspired by the 1942 musical *Holiday Inn*. The past picture, taken in 1979, shows the famous "great sign" the chain used the first few decades after its 1952 founding. Today, the structure houses a Motel 6. (Past, courtesy of Lynch Harper/*East Texas Journal*; present, courtesy of James Buckley.)

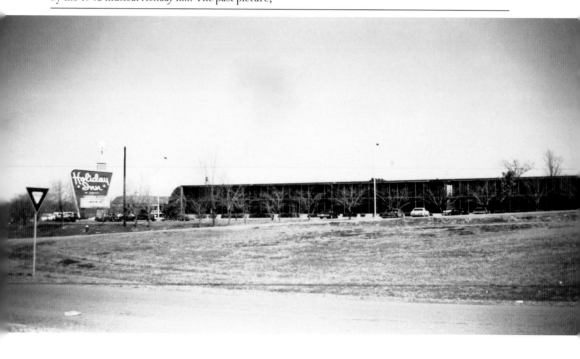

Heading east on Highway 67, also known as Sixteenth Street, to the block just past Edwards Avenue, takes one to the former site of Aunt Ruby Johnson's Café. Located across from the Sundown Motel, Ruby's offered burgers, fries, soda, and ice cream as well as pinball and a jukebox for travelers and others wanting a break. The business suffered from the completion of Interstate 30 drawing traffic farther north. Oakdale Apartments occupies the area where the café used to be. (Past, courtesy of *East Texas Journal*; present, courtesy of James Buckley.)

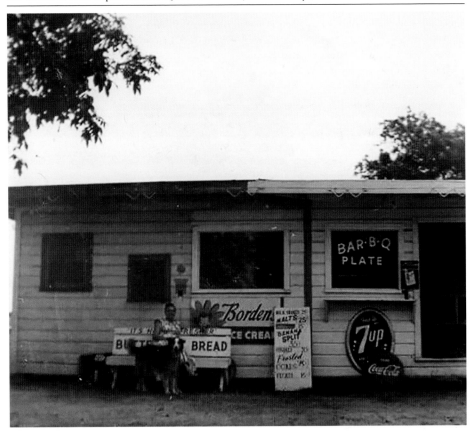

NORTH SIDE: HIGHWAYS, HOTELS, AND HEALTH

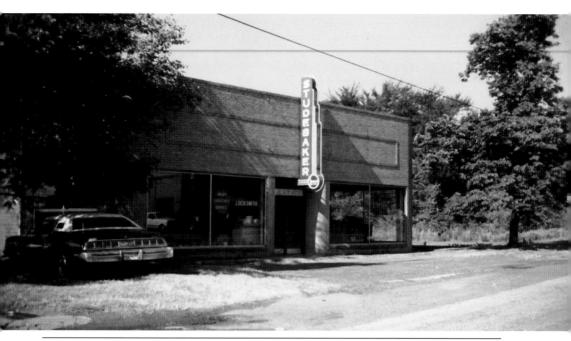

Continuing east on Highway 67 (Sixteenth Street), at the southwest corner of the intersection with Mulberry Street was Dalby Motors. Joe Dalby's Studebaker dealership and garage was one of several car-related businesses that sprang up around Mount Pleasant's network of highways. Studebaker began as a wagon builder in 1852, moving to electric cars in 1904 and gasoline-powered cars in 1911. The building that once housed Dalby's Studebaker dealership is still used for a similar purpose. Auto paint specialist company J&J Paint Supply occupies the building. (Past, courtesy of Lynch Harper/*East Texas Journal*; present, courtesy of James Buckley.)

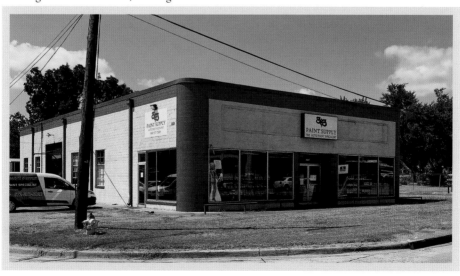

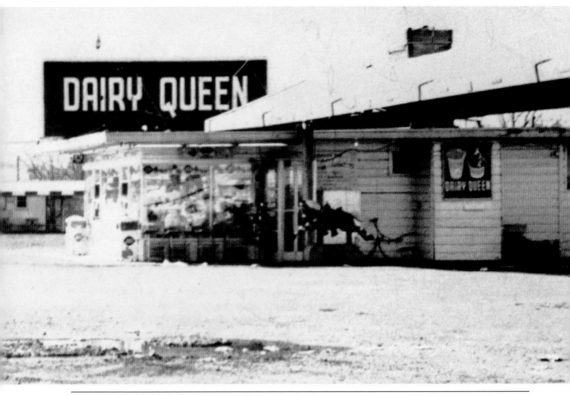

Moving east on Highway 67 (Sixteenth Street), at the northwest corner of the intersection with Jefferson Avenue was the old Dairy Queen, ideally situated to take advantage of tired travelers and vacationers. Although the Dairy Queen chain began in Illinois in 1940, Texas has more franchises than any other state. The location in the 1950s photograph features the original Dairy Queen signage, used from 1940 to 1960. The location currently serves as the parking lot for Pilgrim's Bank. (Past, courtesy of Rex Allen; present, courtesy of James Buckley.)

North Side: Highways, Hotels, and Health

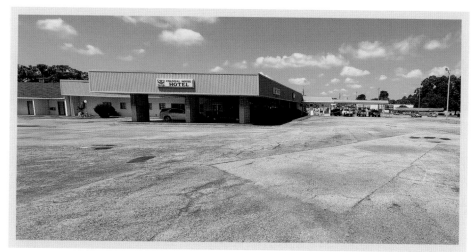

Across the street from the old Dairy Queen, on the southwest corner of the intersection of Highway 67 and Jefferson Avenue, lay the glamorous Gaddis Motor Hotel. The location featured 80 air-conditioned rooms and cabanas, phone service, televisions in every room, and a spacious 5,000-square-foot pool surrounded by palm trees and banana plants. The old Gaddis hotel is currently operating as the Colonial Inn Hotel. (Past, courtesy of *East Texas Journal*; present, courtesy of James Buckley.)

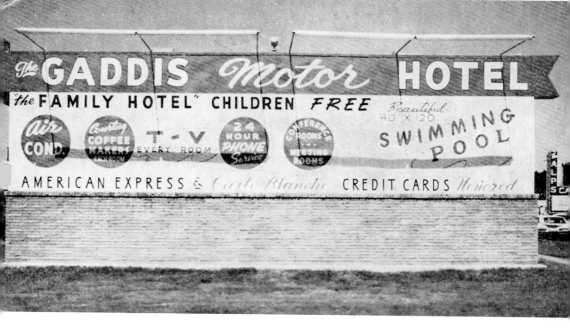

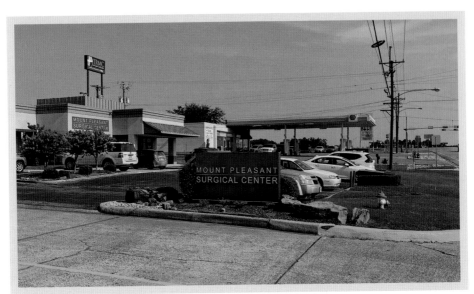

Immediately north of the hospital, on the southwest corner of Jefferson Avenue's intersection with I-30, sat the former Kentucky Fried Chicken. In this 1973 photograph, one can see the Business Highway 271 overpass on the recently opened I-30 visible in the background. The Mount Pleasant Surgical Center currently sits on the lot previously occupied by the restaurant, with a Shell gas station still operating to the north. (Past, courtesy of Lynch Harper/*East Texas Journal*; present, courtesy of James Buckley.)

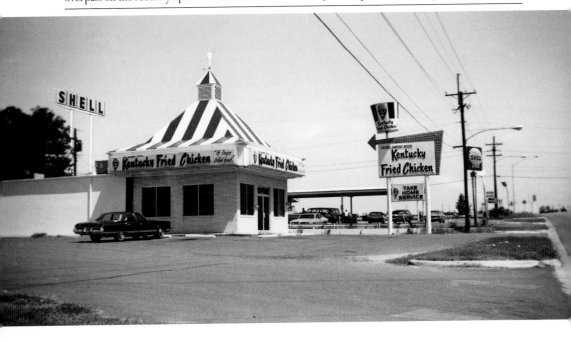

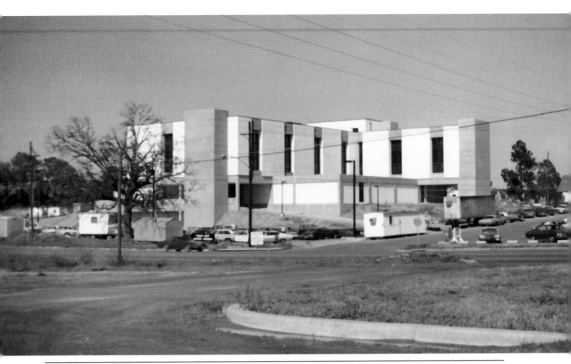

Moving north along Jefferson Avenue, the northwest corner of the intersection with Twentieth Street is the location of the Titus Regional Medical Center (TRMC). Just as Mount Pleasant served as a transportation hub, it would also serve as a regional healthcare hub. In 1950, the people of Titus County approved a bond election for the construction of a 32-bed hospital, which officially opened in 1953. Today, TRMC has 174 beds, 50 medical professionals, and 700 employees. (Past, courtesy of Lynch Harper/*East Texas Journal*; present, courtesy of James Buckley.)

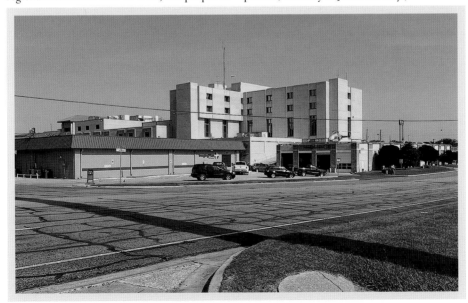

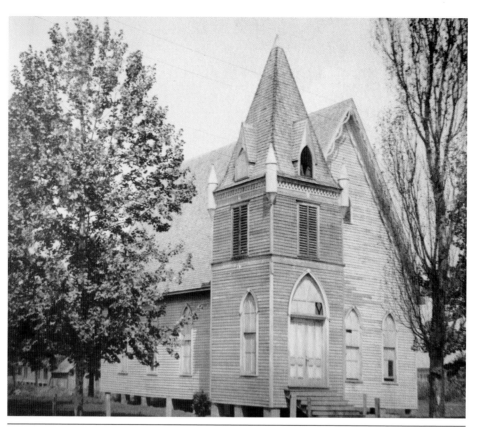

Head north on Jefferson Avenue, then veer onto Green Hill Road for six miles to reach the Greenhill Presbyterian Church. Built in 1860, it is the oldest church in the area still standing. It is also the oldest Presbyterian church west of the Mississippi. The pews, built in 1860 with slave labor, still provide seating inside the original structure. Members of the church eventually formed the First Presbyterian Church in Mount Pleasant in 1881. (Past, courtesy of Mount Pleasant First Presbyterian Church; present, courtesy of James Buckley.)

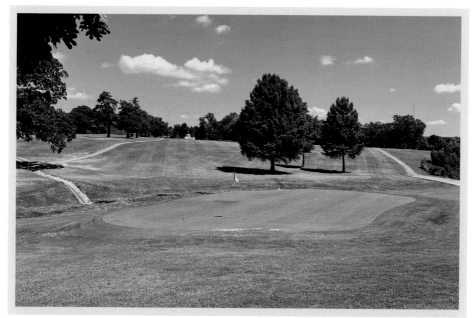

Head back south on Green Hill Road to reach the Mount Pleasant Country Club on the shores of New City Lake. On the opposite shore of the same lake was Lady Bird Johnson's favorite retreat. The golf course, built in 1939, used a combination of private funds and New Deal aid. The photographs are of the sixth hole, one of nine holes designed by Perry Maxwell, best known for his work on the Augusta National golf course. (Past, courtesy of *East Texas Journal*; present, courtesy of James Buckley.)

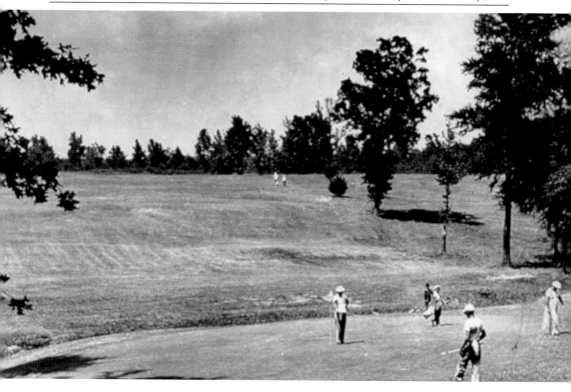

South on Jefferson Avenue, below I-30, is the former Texas National Guard Armory, dedicated in 1955. On November 24, 1964, Pres. Lyndon Baines Johnson and Gov. John B. Connally flew in a two-engine propeller-driven DC-3 that belonged to Lone Star Steel to the Mount Pleasant airport for an appreciation dinner for Marvin Watson, the state Democratic chairman, held at the facility. Starting in 2004, the building has served as Fire Station No. 2. (Past, courtesy of Lynch Harper/*East Texas Journal*; present, courtesy of James Buckley.)

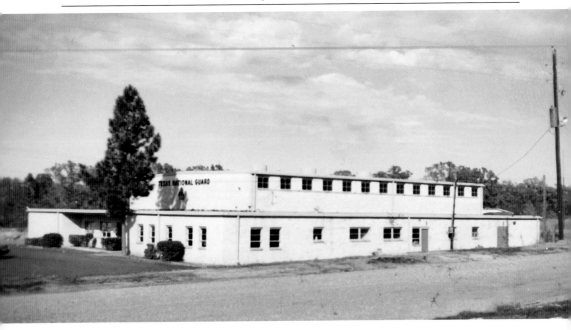

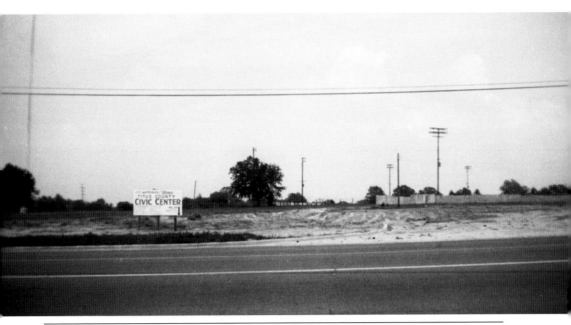

Moving south on Jefferson Avenue takes one to the location of the Titus County Civic Center. The past photograph shows the site where construction began in 1975. The center was envisioned as a way to provide a place for community events, large gatherings, and corporate presentations. With over 21,000 square feet of space and generous parking, it has served that purpose then and now. (Past, courtesy of Lynch Harper/*East Texas Journal*; present, courtesy of James Buckley.)

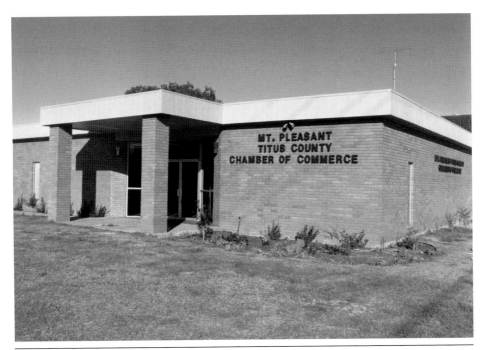

On the northeast corner of Jefferson Avenue and Highway 67 is the Titus County Chamber of Commerce. The chamber has been fulfilling its mission to provide impactful and inclusive opportunities for businesses and advance the general welfare and prosperity of Northeast Texas since its founding in 1939. The chamber has functioned from this corner location since 1976. (Past, courtesy of Titus County Chamber of Commerce; present, courtesy of James Buckley.)

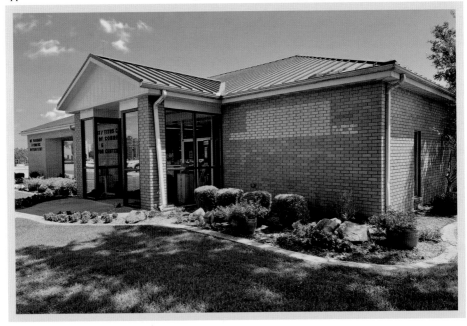

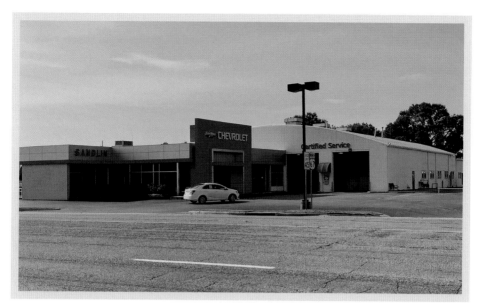

On the southeast corner of Highway 67 and Jefferson Avenue is one of the many dealerships that sprang up to meet the demand created by the nation's growing highway system, Bob Sandlin Motors. Sandlin realized the potential for profit in the hub of Northeast Texas and left a position in Henderson to partner with Chevrolet in 1937. The company prospered in the aftermath of World War II and continues to conduct business in the same location. (Past, courtesy of Lynch Harper/*East Texas Journal*; present, courtesy of James Buckley.)

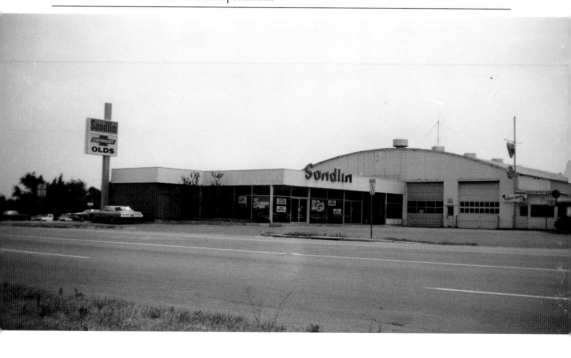

Heading back to US 67 (Sixteenth Street) and west takes one to the site of the former Hillcrest Hotel, designed to take advantage of America's love affair with the automobile that exploded after World War II. Conveniently located just off Highway 67, the Hillcrest Motel advertised free television and air-conditioning. Unfortunately, many of these old motels, including the Hillcrest, are no longer operating, largely because of the shifting traffic patterns caused by the construction of Interstate 30, which was completed in 1971. Currently, the lot once occupied by the Hillcrest Motel is home to the industrial equipment supplier Purvis Industries. (Past, courtesy of *East Texas Journal*; present, courtesy of James Buckley.)

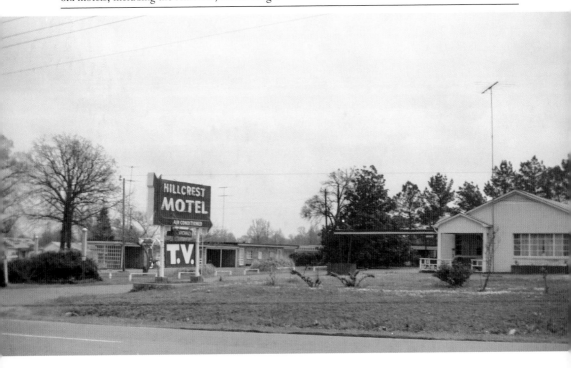

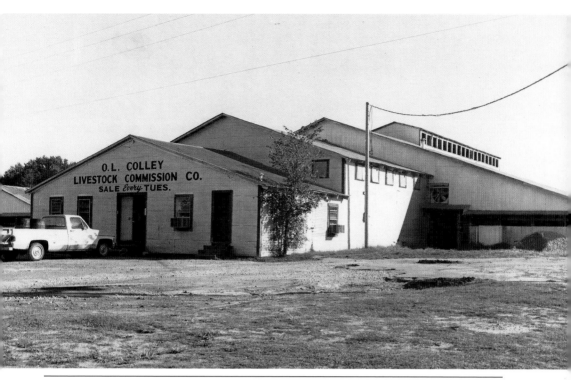

Continue east down Highway 67 to the intersection with Industrial Road. The O.L. Colley Livestock Commission, pictured in 1967, provided auction services for local ranchers to sell their livestock. Stone Livestock Commission has provided similar services at this same location since 2002. (Past, courtesy of Mount Pleasant Chamber of Commerce; present, courtesy of James Buckley.)

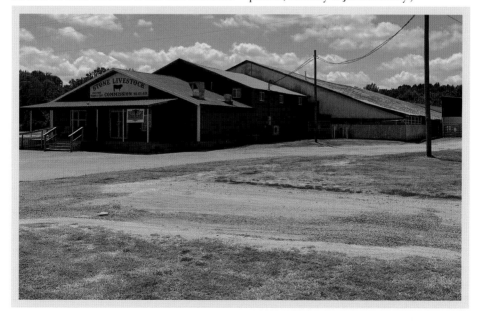

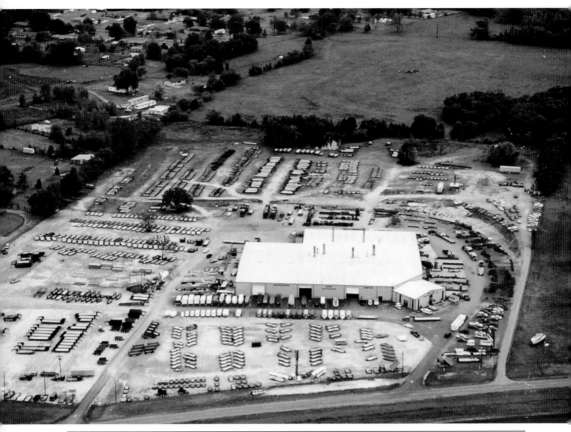

Heading west on Interstate 30 takes one to the location of the Big Tex Trailer Manufacturing plant. Ricky Baker founded the company in Odessa and then relocated it to Mount Pleasant in 1997. Today, Big Tex is part of American Trailer World and is the largest manufacturer, retailer, and distributor of professional and consumer grade trailers, truck equipment, and parts and accessories in North America. (Past, courtesy of Big Tex Manufacturing; present, courtesy of Mayben Realty.)

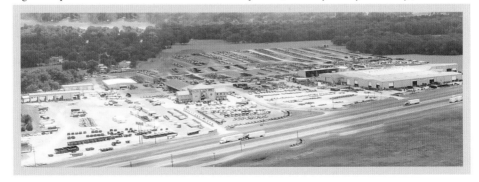

North Side: Highways, Hotels, and Health

SOUTH SIDE

SPRING WATERS, TRAILERS, AIR TRAVEL, AND EDUCATION

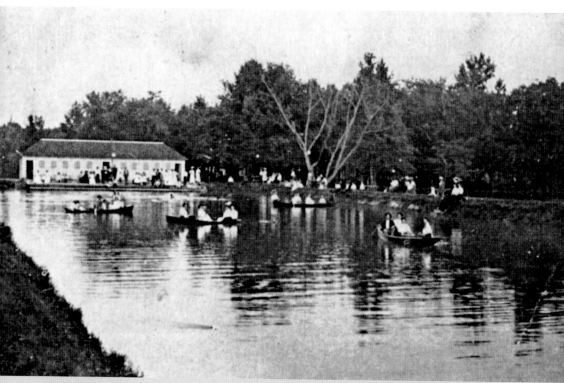

The south side of town showcases many of the original reasons that brought people to the location as well as some of the more unique aspects of the town. This photograph shows the man-made lake that allowed guests to boat, fish, and swim at Dellwood Resort, where people enjoyed the natural mineral springs that flow in the area. The lake was in the southeast corner of present Dellwood Park, where Florey Avenue and Dellwood Drive meet, near Town Branch Creek. (Courtesy of City of Mount Pleasant Public Library and Historical Museum.)

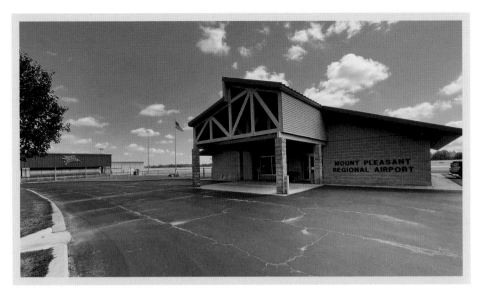

From the courthouse in the town's center, follow Jefferson Avenue nine miles south to the location of the Mount Pleasant Regional Airport, which opened in 2002, making it the newest airport in the state. In 2005, the Texas Department of Transportation named it Airport of the Year and manager Paul Henderson Airport Manager of the Year. It has 64 hangars and is home to the Mid-America Flight Museum, a unique world-class museum with more flightworthy aircraft than any other museum. In March 2016, Scott Glover, director of the Mid-America Flight Museum, played an instrumental role in having the original Air Force One land in Mount Pleasant en route from Arizona to Virginia to undergo restoration, bringing national attention to the regional airport and museum. (Past, courtesy of Mount Pleasant Regional Airport; present, courtesy of James Buckley.)

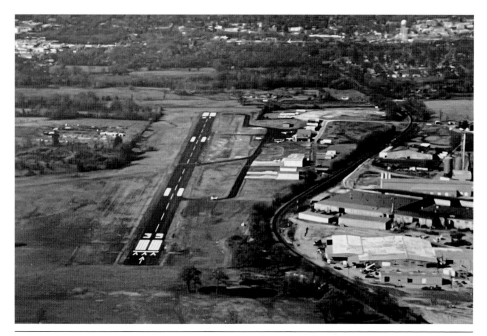

Heading north two miles from the current Mount Pleasant Regional Airport is the earlier airport location. The city has had four different locations to satisfy the needs of the aerial-minded. In the early 20th century, barnstormers flew off what was once called Redfearn's Hill. After the Second World War, E.P. Hendricks used a graded flat area of pasture land off Highway 67, across from what is currently IMFAB Inc., as a flight school and to provide rides until it was decommissioned in 1947. Gus Hoffman built the first airport with paved runways that year and sold it to the city in 1953. The city owned the old airport until 2002, when the new airport was completed. When the airport relocated, nearby Priefert Manufacturing expanded into the space. (Past, courtesy of Mount Pleasant Regional Airport; present, courtesy of Priefert Manufacturing.)

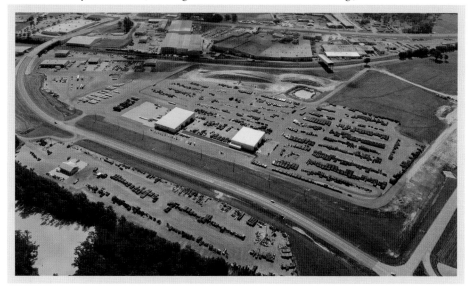

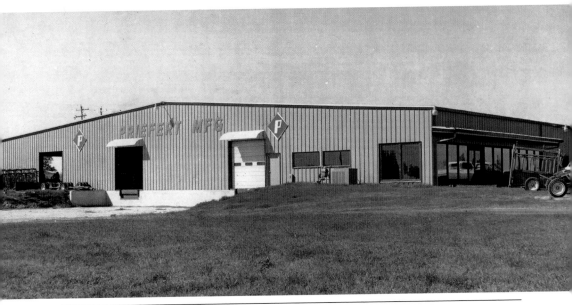

Near the same location as the former airport, Priefert expanded and eventually swallowed up the entire property. In 1964, Marvin Priefert invented the first gliding-action, fully opening headgate and marketed and sold it himself. In 1980, his company built a new 27,000-square-foot facility on Highway 271 and moved the entire operation, including some of the original machines Priefert built. Today, it is one of the top farm, ranch, and rodeo equipment companies in the world. (Past, courtesy of Mount Pleasant Chamber of Commerce; present, courtesy of Scott Fulgham.)

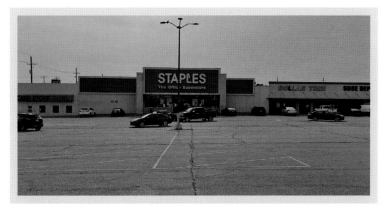

Just north of the former airport was the location of the very first Walmart in the state of Texas. Sam Walton flew into the Mount Pleasant airport and reportedly stated that "they had a good little airport" and that the city would make a good spot for Walmart. Store 131's opening day was November 11, 1975. Walmart outgrew its original building and eventually moved across the street, allowing other retailers to move into its former location. (Past, courtesy of *East Texas Journal*; present, courtesy of James Buckley.)

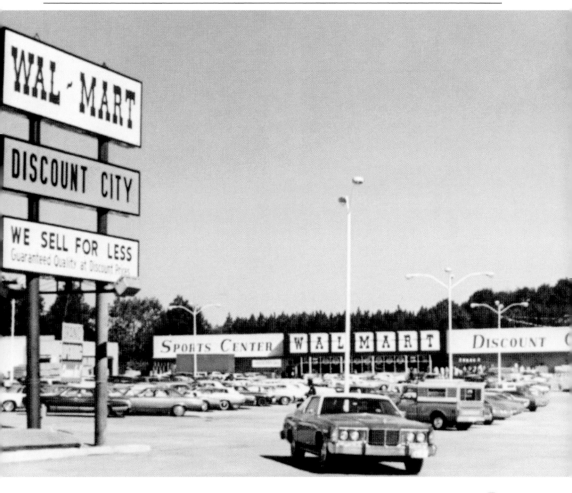

Moving north on Jefferson Avenue, then east on Alexander Road to McMinn Avenue, one will find the former South Ward School. In the early 20th century, the various elementary schools in town were designated East Ward, West Ward, and South Ward. South Ward was the most recent of them, founded in 1954. Today, the South Ward School is known as E.C. Brice Elementary. (Past, courtesy of Rex Allen; present, courtesy of James Buckley.)

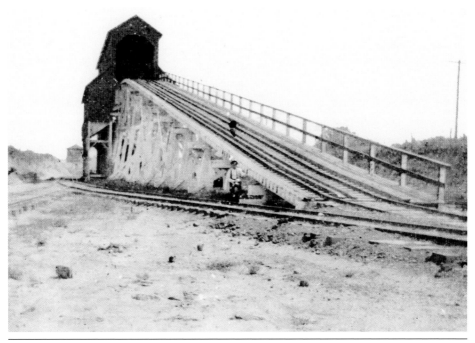

From the school, head back to Jefferson Avenue, then continue moving north. Behind the present-day Jefferson Park Shopping Center, not too far from the current water tower, was a coal chute. The 1908 St. Louis Southwestern Railway (Cotton Belt) annual report notes the cost for building a new coal chute with 20 pockets in Mount Pleasant as $8,821. Such a large number of pockets indicates the importance of Mount Pleasant to the railway line. The same annual report notes that connections with the city waterworks cost $856. Coal served as the fuel source to heat water, which generated the steam necessary to move the locomotives. Railways transitioned to electric and diesel starting in the 1930s. (Past, courtesy of *East Texas Journal*; present, courtesy of James Buckley.)

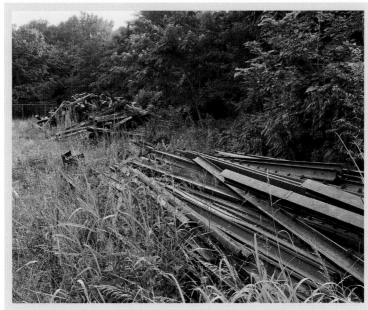

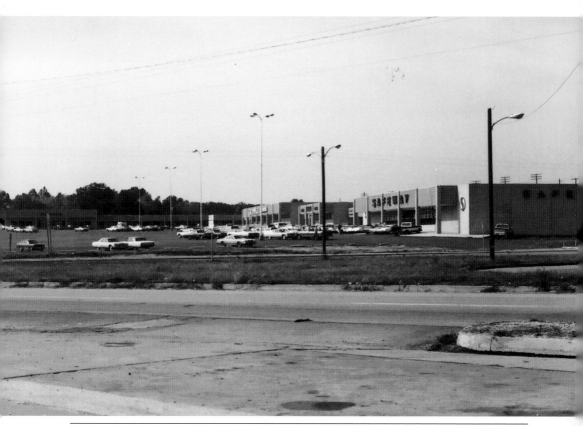

On the southwest corner of the intersection of Jefferson Avenue and Ferguson Road is the Jefferson Park Shopping Center. The shopping center strategically straddles the intersection of two major highways, US 271 and Texas 49. The location continues to take advantage of new travel innovations, as evidenced by the electric vehicle charging stations near the gas pumps. Super One occupies the location where Safeway used to be. (Past, courtesy of Mount Pleasant Chamber of Commerce; present, courtesy of James Buckley.)

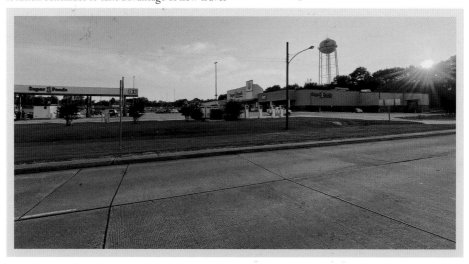

Looking north from the intersection of Jefferson Avenue and Ferguson Road, one can see the Cotton Belt crossing as it appeared in 1969. Built in 1931, the 80-foot-long steel stringer bridge allows two lanes of traffic to cross below the railroad. As the town grew, what was originally two-way traffic became a one-way route heading north. (Past, courtesy of Lynch Harper/*East Texas Journal*; present, courtesy of James Buckley.)

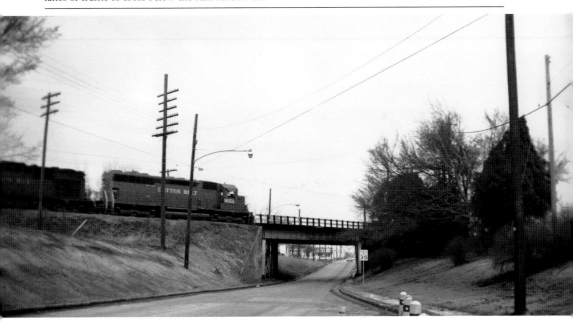

Looking south down Jefferson Avenue at the intersection with Ferguson Road, one can see what used to be the intersection between Texas Highways 49 and 65, as revealed in the lower, less-reflective signs of the 1920s and early 1930s. Highway 49 follows the former Choctaw Trace, originally ending when it met Highway 65. Highway 65 was established in 1923, cosigned with Hwy 271 in 1935, and canceled in 1939. Today, the same location is the intersection of an expanded Highway 49 and US Highway 271. (Past, courtesy of City of Mount Pleasant Public Library and Historical Museum; present, courtesy of James Buckley.)

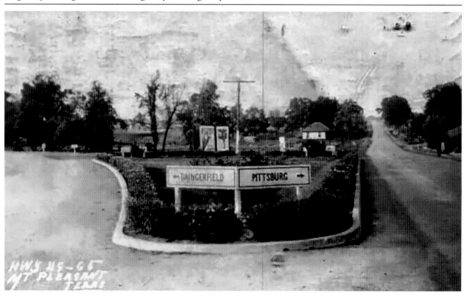

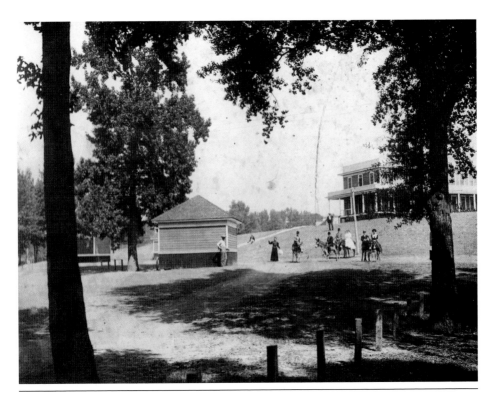

Following Highway 49 east of town, the road moves in a southerly direction toward Town Branch Creek, where in the 1890s, Jesse Reed ran a camp and sold access to mineral spring waters. The Red Mineral Springs Development Company built the elaborate Dellwood Resort, with many amenities and activities for visitors, from mineral spring baths to dances and fishing. (Past, courtesy of City of Mount Pleasant Public Library and Historical Museum; present, courtesy of James Buckley.)

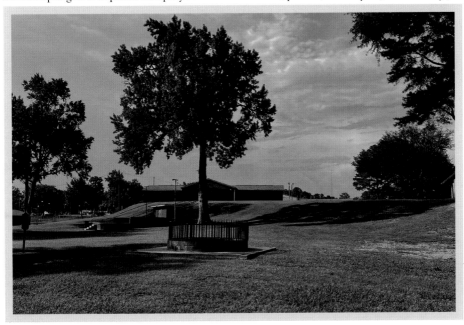

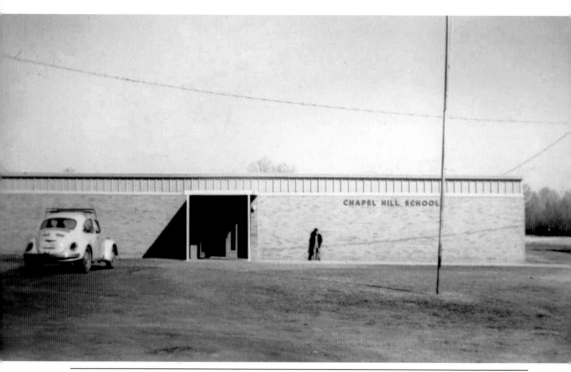

Continuing east along Highway 49 to FM 1735, then south on that route, takes one to the Chapel Hill School. Chapel Hill College had opened close to Daingerfield in 1852, and the rural community south of town continues the name. Prominent individuals from the school include a governor of Texas, O.B. Colquitt; a commissioner of the General Land Office of Texas, J.T. Robinson; and a professor of mathematics at Baylor University, Jesse Breland Johnson. (Past, courtesy of Lynch Harper/*East Texas Journal*; present, courtesy of Scott Fulgham.)

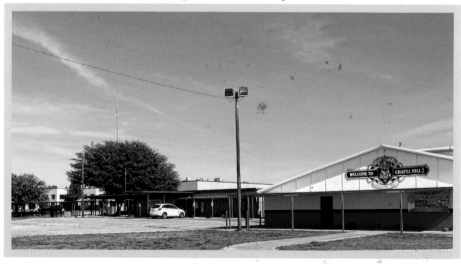

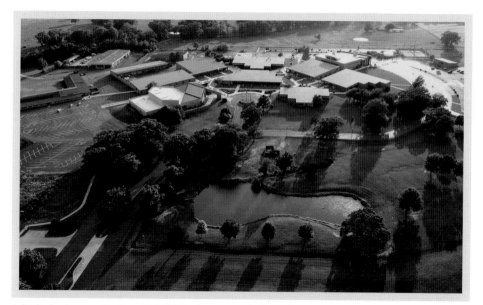

A little farther south along FM 1735 takes one to Northeast Texas Community College. Built in 1984, making it one of the youngest community colleges in the state, it has since gone on to national prominence. It is the only community college in the nation offering a Work4College program to help students graduate debt-free. The Carroll Shelby Automotive Program bears the name of the famous race car driver and automotive designer born nearby. (Both, courtesy of Northeast Texas Community College.)

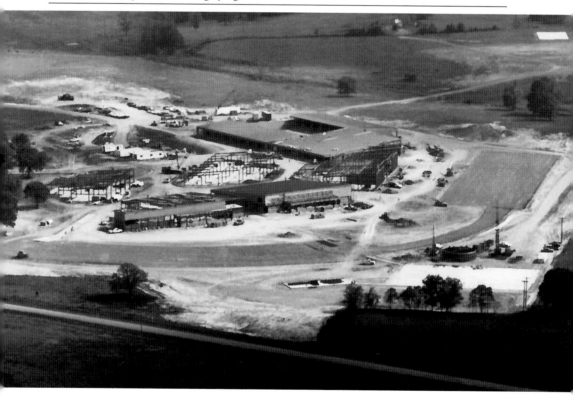

DISCOVER THOUSANDS OF LOCAL HISTORY BOOKS FEATURING MILLIONS OF VINTAGE IMAGES

Arcadia Publishing, the leading local history publisher in the United States, is committed to making history accessible and meaningful through publishing books that celebrate and preserve the heritage of America's people and places.

Find more books like this at
www.arcadiapublishing.com

Search for your hometown history, your old stomping grounds, and even your favorite sports team.

Consistent with our mission to preserve history on a local level, this book was printed in South Carolina on American-made paper and manufactured entirely in the United States. Products carrying the accredited Forest Stewardship Council (FSC) label are printed on 100 percent FSC-certified paper.

MADE IN THE USA